IMAGES
of America

WOODLEY PARK

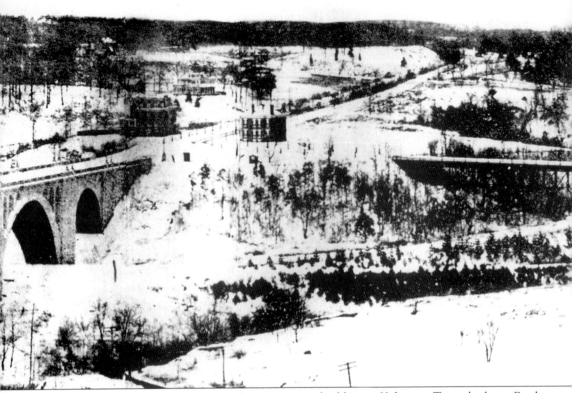

This winter 1908 view from the Mendota apartment building in Kalorama Triangle shows Rock Creek Park and the two original bridges that connected the emerging suburb of Woodley Park to the city of Washington, D.C. At the time, only a few impressive mansions graced Connecticut Avenue, and large open lands are visible where thousands of rowhomes are located today. (LOC.)

IMAGES
of America

WOODLEY PARK

Paul K. Williams and Gregory J. Alexander

ARCADIA

Published by Arcadia Publishing,
an imprint of Tempus Publishing, Inc.
2 Cumberland Street
Charleston, SC 29401

Printed in Great Britain.

Library of Congress Catalog Card Number: 2002117620

For all general information contact Arcadia Publishing at:
Telephone 843-853-2070
Fax 843-853-0044
E-Mail sales@arcadiapublishing.com

For customer service and orders:
Toll-Free 1-888-313-2665

Visit us on the internet at http://www.arcadiapublishing.com

This 1902 map shows Woodley Park before residential development began in the 1910s. On this map, the area left of the National Zoological Park and below Cleveland Park would later become Woodley Park, a neighborhood that had its boundaries delineated in the mid-1870s as a subdivision of rural property but avoided substantial building construction until the building boom of 1905–1929. (CPHS.)

CONTENTS

ACKNOWLEDGMENTS

Many people made the production of this book possible, especially Laura Daniels New at Arcadia Publishing for keeping us on track with deadlines and advice. We also thank family members, friends, and of course the "Balt Nine." Thanks also goes to the staff of the Prints and Photographs Division of the Library of Congress (LOC), Historical Society of Washington (HSW), Judy Waxman of the Woodley Park Historical Society, the staff of the Washingtoniana Division of the Martin Luther King Jr. Memorial Library (MLK), Judy Hubbard Saul of the Cleveland Park Historical Society (CPHS), and Kelton "K.C." Higgins and Katherine Brown for hours of photographic research. Also, mention must go to Father Brennan of St. Thomas Church, and to Santa and Jose of Secrets Excellence in Punta Cana for their assistance with El Presidente. And finally, thanks to Molly Hurwitz of Burton Travel for providing the perfect locale to write this book.

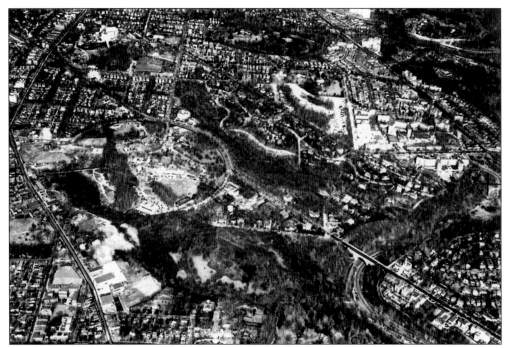

This aerial view shows the proximity of Woodley Park to Massachusetts Avenue Heights, Rock Creek Park, and Massachusetts Avenue. The Chevy Chase Land Company (organized in the late 1880s by Senator Newlands of Nevada) owned much of the land bordering Connecticut Avenue between the Taft Bridge and the outer District Line, which they had bought up in parcels under assumed names and companies. Newlands had a belief that cities had a tendency to grow westward and financed a streetcar line up Connecticut Avenue beginning in 1892 that led to his planned community of Chevy Chase. (HSW.)

INTRODUCTION

The history of Woodley Park may not be as long as the histories of some of the neighboring areas of Washington, D.C.; however, what it lacks in longevity, it definitely makes up for in notoriety.

Today, Connecticut Avenue—Woodley Park's primary thoroughfare—is lined with large apartment buildings and a bustling commercial strip. However, as recent as the late 1800s and early 1900s, Woodley Park was still void of significant development. Instead, it was an area of wide-open lands with a few stately mansions scattered throughout. These early estates were refined in appearance, and even more important were the noteworthy occupants who resided there. United States presidents and notable politicians, as well as some of Washington's elite residents, have made a home in some of the early Woodley Park estates. Although several homes have played a vital role in forming Woodley Park's history, the most notable of the early estates was "Woodley," a beautiful Georgian mansion for which the neighborhood was named.

Interestingly, it would be more than 100 years after the construction of the Woodley estate before Woodley Park would experience the housing boom that eluded the neighborhood for so long. After the completion of several key bridges across Rock Creek Valley—which for years was viewed as an obstacle not worth tackling for residential development—Woodley Park finally caught the attention of those looking to settle in a neighborhood on the rise. In the early 1900s, the housing boom finally hit Woodley Park, and the neighborhood was fortunate enough to have buildings designed by some of the country's finest architects and developers, including Harry Wardman, Clarke Waggaman, William Allard, and George Santmyers.

The housing boom also spurred the rise of grand apartment buildings, small and large businesses, and increased places of worship. The apartment building boom was vital to the success of Woodley Park and forever changed the landscape of the area. The Kennedy-Warren, Westchester, the Delano, and Cathedral Mansions, among others, created an immediate impact on Woodley Park, making way for thousands of new residents to make the once sleepy neighborhood their home. The residential influx also created the need for hotels in the area, and Woodley Park was graced by two Washington landmarks—the famed Shoreham Hotel, which has hosted political figures as well as Hollywood icons, and the Wardman Hotel, which was initially predicted to fail as insiders still viewed Woodley Park as "the country." Instead, the Wardman Hotel helped draw downtown residents to Woodley Park to discover the many amenities it had to offer.

Once Washingtonians and tourists discovered Woodley Park, they found impressive architecture, large elegant homes, and convenient entertainment venues set in a peaceful atmosphere. Along with thousands of others over the years, they also discovered the National Zoological Park, Rock Creek Park, and the Washington National Cathedral—all situated today in this tranquil neighborhood.

The National Zoo, which originated in the late 1800s, has been a national and international leader in animal conservation, while also providing tourists memorable moments and glimpses into the lives of species from all over the world. Woodley Park is fortunate to be home of Rock Creek Park. Formed in 1890 "for the benefit and enjoyment of the people of the United States," Rock Creek Park provides Woodley Park residents with ample recreational opportunities and

an escape from hectic day-to-day life. The Washington Cathedral, too, provides a peaceful escape and an opportunity for spiritual discovery for all faiths. All have played pivotal roles in the transformation of Woodley Park, not to mention the construction of the Metro station in December of 1981, which brought still more people.

The Woodley Park of today is roughly bounded by Calvert Street and Cleveland Avenue to the south, Klingle and Woodley Road to the north, Rock Creek Park on the east, and Wisconsin Avenue to the west. For the purposes of this text, the authors have also included a brief history of Massachusetts Avenue Heights, adjoining Woodley Park to the south, as well as a history of the National Cathedral that anchors the expanded neighborhood to the west. However, a smaller core of old Woodley Park was recognized as a local and national historic district in 1990.

In this historical book, the authors hope to shed some light on the neighborhood's illustrious past from farmlands and solitude to one of Washington's most sought-after upscale residential neighborhoods and a tourist destination for thousands of people each year.

One

EARLY ESTATES

Since the early 1800s, grand estates have graced Woodley Park and have been home to United States presidents, notable politicians, and some of Washington's—and the nation's—elite residents. From Grover Cleveland to Francis Scott Key to John Quincy Adams, historic figures have made elegant homes in Woodley Park's famed estates.

Probably the most notable of the early estates was "Woodley"—a Georgian manor house estate that stood on 18 acres of land surrounded by impressive oak and chestnut trees. Woodley—from which Woodley Park's name derives—was originally part of a much larger tract of land owned by George Beall in 1720 and Gen. Uriah Forrest in the 1790s. Forrest would later sell part of the land to his brother-in-law, Philip Barton Key, who built Woodley between 1800 and 1804. Key's nephew, Francis Scott Key, spent considerable time at the estate. The Keys lived in great luxury and entertained lavishly at the house and grounds.

Woodley, which still stands today at 3000 Cathedral Avenue, N.W., has also been the summer home for four United States presidents—Martin Van Buren, John Tyler, James Buchanan, and Grover Cleveland. Van Buren reportedly took refuge at Woodley during the summer and fall months to escape the heat and malaria-breeding mosquitoes of the city.

Another historic estate in the area is the famous Holt House on the grounds of the National Zoo. Named for the home's third owner, Dr. Henry Holt, the Holt House was built between 1809 and 1818 and later was owned by John Quincy Adams, Andrew Jackson, and Martin Van Buren. The National Zoo bought it and the surrounding land in 1889.

Other grand estates in Woodley Park also hold their place in history. Redwood, which was built in 1819, was once the home of Jefferson Davis, and during the Civil War was heavily guarded after Union soldiers looted the estate's large fruit farms and forced the homeowners to flee into the city. Single Oak was built in the early 1900s by Sen. Francis Newlands, while the Wardman estate was built in 1909 by famed developer Harry Wardman at the corner of Connecticut Avenue and Woodley Road. However, while Mrs. Wardman was in Paris attending to their daughter Helen's education, Wardman had the furnishings removed, razed the house, and began construction of the Wardman Towers, the apartment annex to the hotel. Redwood was also razed for an apartment building, and an estate on the National Cathedral grounds known as "Beauvoir" also made way for what many coined as "progress." However, several of the early estates are still extant and enjoyed to this day.

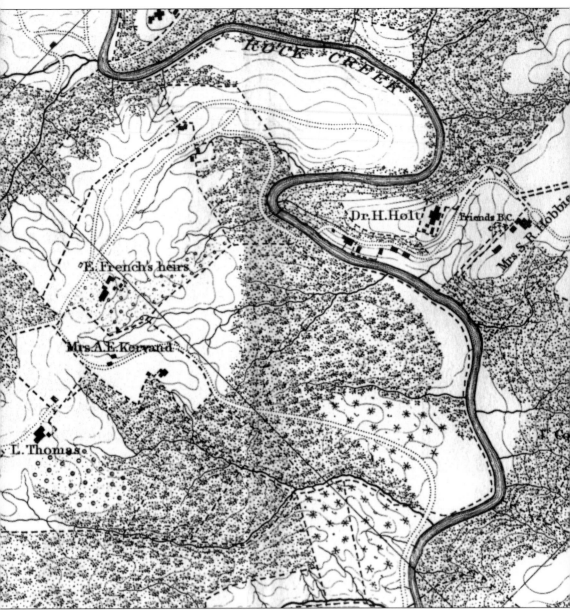

The earliest map showing landholding in Woodley Park is *Boschke's Topographical Map of the District of Columbia*, published in 1861. The map shows property with a house belonging to Mrs. A.E. Kervand, seen here on the left side of the image. Her property, roughly the shape of large teardrop, eventually became the heart of Woodley Park. Also pictured to the right of Rock Creek is property belonging to Dr. H. Holt, location of the famous Holt House that in 1889 would become property of the National Zoo. (CPHS.)

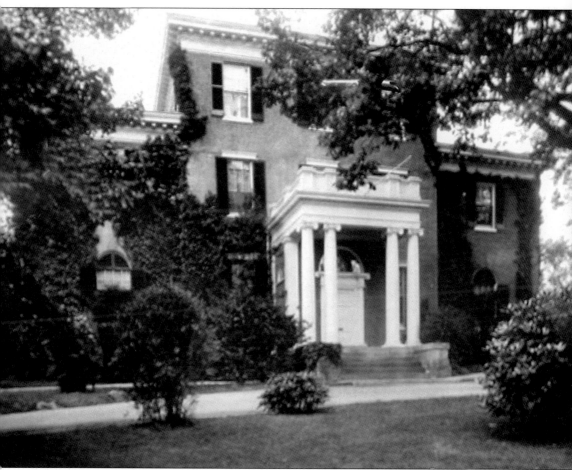

The construction date of Woodley, located at 3000 Cathedral Avenue, is believed to be around 1800, but the first documented record of occupation dates to 1804 when the fourth child of Philip Barton and Ann Key was born there. Constructed with bricks from England, Woodley has been said to be the summer home of four United States presidents—Martin Van Buren, John Tyler, James Buchanan, and Grover Cleveland. Woodley also was the home to German Ambassador Baron Gerault, Col. E.M. House of Woodrow Wilson's first administration, and Secretary of State Henry Stimson. (LOC.)

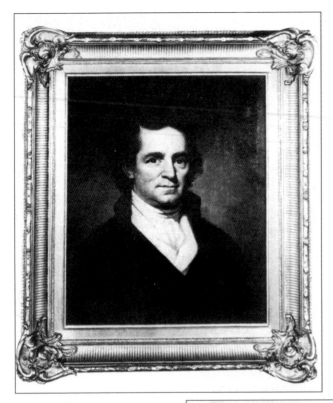

Philip Barton Key, uncle of Francis Scott Key, built the Woodley estate around 1800. As a Loyalist, he fought with the British Army during the Revolutionary War, and due to his refusal to sign the Articles of Association, had his landholdings confiscated. However, after the war, he became an important lawyer and served in the Maryland State legislature and the United States Congress. (CPHS.)

In 1790, Key married Ann Plater, daughter of the Honorable George Plater, who, in 1791, would become governor of Maryland. Upon Key's death in 1817, his widow abandoned the Woodley estate and returned to Georgetown to a home at the corner of 31st and N Streets. (CPHS.)

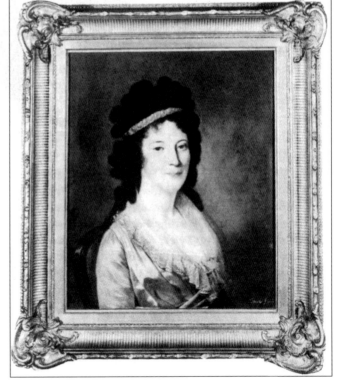

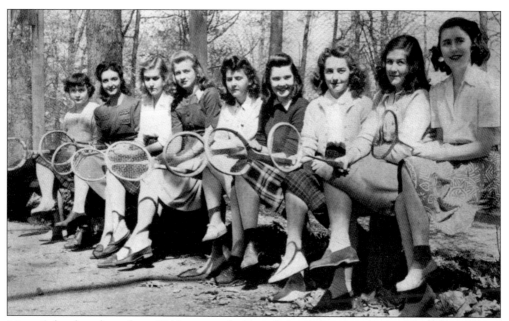

Maret School students from 1944 are seen here ready for their tennis lesson. The Maret School once was located at 2118 Kalorama Road, but in June of 1950, the school purchased the estate known as "Woodley," for which Woodley Park was named. However, due to zoning ordinances, the school was unable to occupy the building until June 1952 and only after the District Board of Zoning Adjustment reversed an earlier ruling. (MLK.)

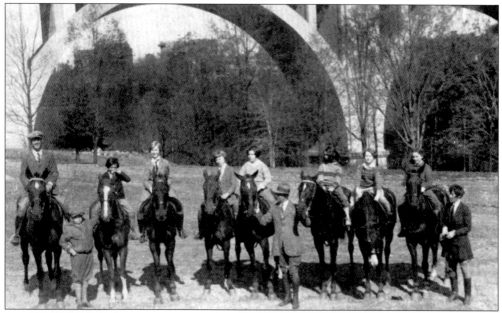

Students from the Maret School are shown enjoying a horseback ride in Rock Creek Park in preparation for the annual springtime horseshow competition in 1942. Recreational activities were plentiful at the school and included tennis, basketball, skating, playground games, football, baseball, folk dancing for girls, and swimming, which was held at the Shoreham Hotel swimming pool. (MLK.)

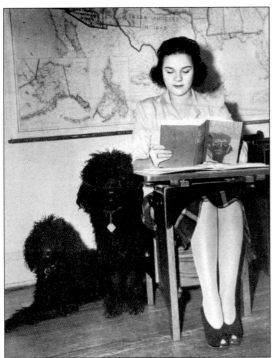

This 1944 image shows the two Maret School French poodles, Cyrano and Caniche, sitting in on a class discussion. The poodles were said to be "known and loved by all the pupils." (MLK.)

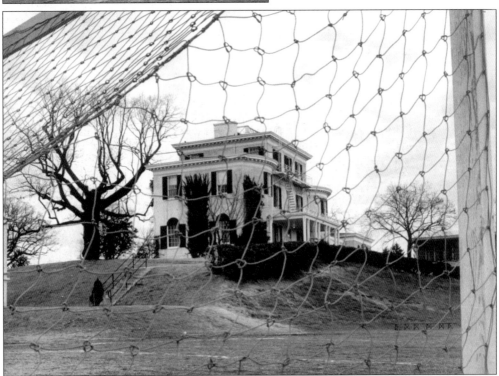

The Maret School is seen here in the background through a soccer net. Two months after the Maret School took occupation of the Woodley estate, a massive fire seriously damaged the east wing. However, the school immediately made necessary repairs. (MLK.)

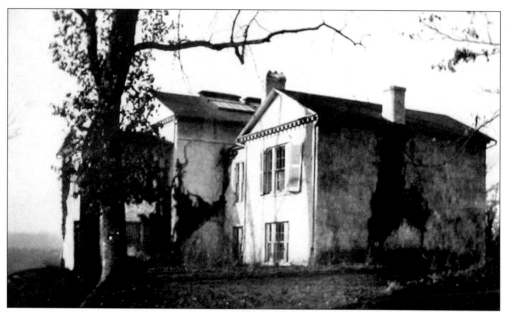

The residence that would later be called the Holt House is seen here around 1900. The exact date of construction is unknown; however, researchers believe that the house was constructed between 1809 and 1818, when George Johnson resided at the property. Accounts indicate that George Johnson invested $50,000 for improvements at the mills, some of which may also have been used to build a residence. After George Johnson's father, Roger, died in 1835, the property was sold to Dr. Ashton Alexander, a prominent physician from Baltimore. (LOC.)

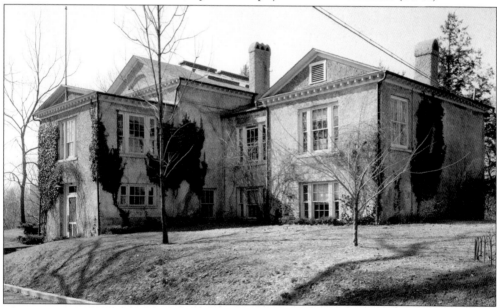

This 1937 image of the Holt House illustrates its impressive front façade. The home is named after its third owner, Dr. Henry Holt, originally of Oswego County, New York, who purchased the property in December 1844 from Ashton Alexander. Despite his medical title, Holt farmed the property. Prior to Holt residing in the home, it was occupied by John Quincy Adams, Andrew Jackson, and Martin Van Buren. (Photograph by John O. Brostrup, HABS, LOC.)

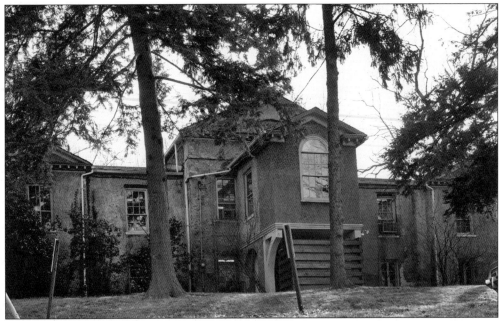

Dr. Henry Holt was the first owner to live in the house. Alterations were made during his tenure at the home, including the addition of a new entrance on the north side and verandahs on the south side. These changes altered the overall appearance of the structure. (Photograph by John O. Brostrup, HABS, LOC.)

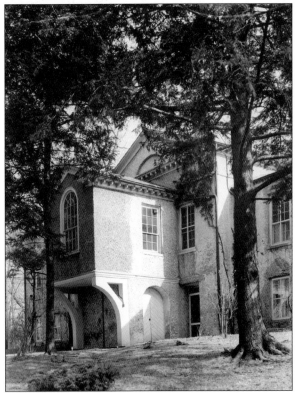

This 1937 image of the historic Holt House does not include the original farm buildings, built for livestock, that are no longer standing. Holt's farming business suffered, as he was forced to borrow money and used the farm as collateral for most of the time he remained on the land. Dr. Holt and his family sold the property to the Commissioners for the National Zoological Park in 1889 for $40,000. (Photograph by John O. Brostrup, HABS, LOC.)

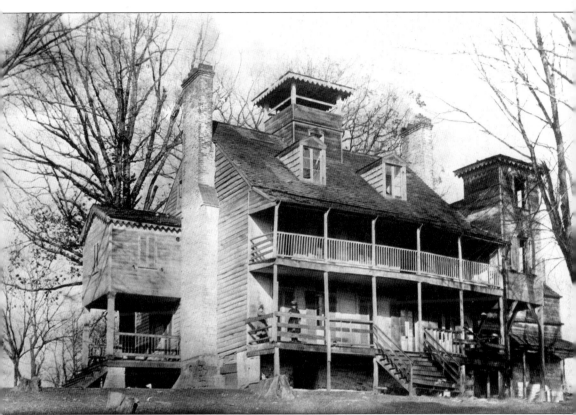

Oak Hill at 3000 Connecticut Avenue, also known as Redwood, was built c. 1819 and was located across from the Connecticut Avenue entrance to the National Zoo. Once the home to Jefferson Davis in 1856 and a fashionable resort during James Buchanan's presidency, the home was razed c. 1920 to make way for the Cathedral Mansions apartments. Varina Howell, wife of Jefferson Davis, wrote in 1856 that "at midsummer we took a house two or three miles out of town, and spent the heated term there. Mr. and Mrs. [Franklin] Pierce used frequently to come for us for the day, and such intimate talks, such unrestrained intercourse and pleasantries exchanged are charming memories." (LOC.)

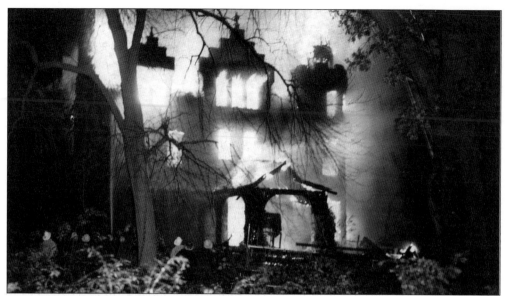

This image appeared in the *Washington Daily News* and shows the November 7, 1949 burning of the Clifton Mansion, which once stood at 3041 Whitehaven Street. It was built in 1880 by Col. James Elverson, publisher of the *Philadelphia Inquirer*, but had not been occupied for more than 25 years prior to the time of the fire. Other early estates were also damaged by fires, including Woodley in 1952, two years after the Maret School purchased the home. (MLK.)

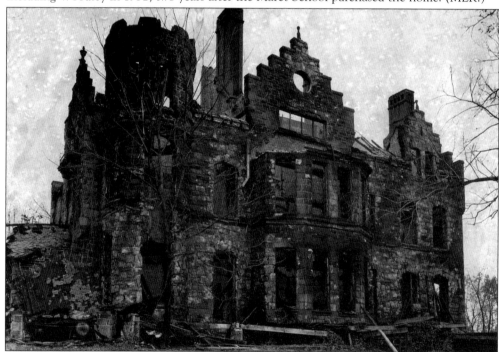

The devastation caused by the dramatic 1949 fire at the Clifton Mansion can be seen here. The long-abandoned house was coined the "Ghost Mansion" by area children, and at the time of the loss, was owned by socialite Mrs. Truxton Beale, who resided in the Decatur House in Lafayette Square. The cause of the fire was blamed on "children or tramps." (MLK.)

The "Single Oak" estate, seen here in 1951, was built by Sen. Francis G. Newlands, founder of the Chevy Chase Land Company, as a family residence. Shortly before World War II, it was bought by the Swiss Legislation and occupied by the Minister of Switzerland. (HSW.)

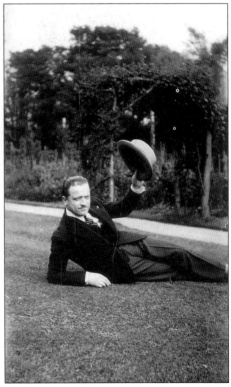

According to his own accounts, Harry Wardman left home in England and made his way to New York as a stowaway aboard the *Brittania* in 1889, although he had originally been bound for Australia. Soon after, he was offered a job at Wanamaker's Department Store in Philadelphia, before heading to Washington in 1895 with his first wife, Mary Hudson, who died just five years later. He is seen here in a rare jovial moment on the lawn of his mansion built in Woodley Park during the peak of his building career. (HSW.)

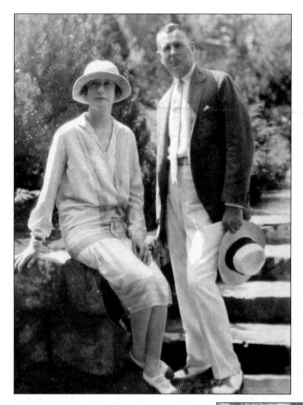

Wardman's first job in Washington was that of a carpenter, laying floors in the apartment buildings built by Bates Warren. He had not been in Washington long before he went into business for himself, with the construction of a few modest houses beginning in 1897. Wardman married his second wife, Lillian Glascock of Asheville, North Carolina in 1908. They soon departed for a three-month honeymoon in Europe, including a visit to Egypt. (HSW.)

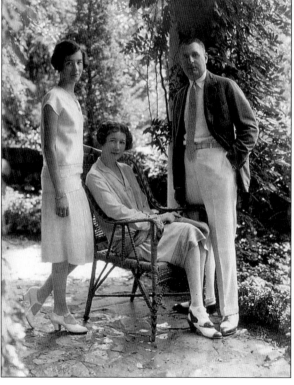

The Wardman house featured a stable and garages on the expansive grounds, which housed a pony that daughter Helen was often seen riding. The house was also the site of a festive wedding for daughter Alice in 1916, with many prominent residents of Washington in attendance. (HSW.)

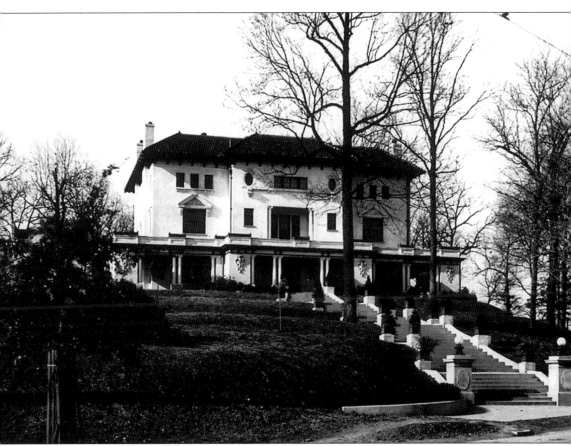

Despite a written desire to retire in England, Wardman built an impressive home in 1909 on what is today the site of the Wardman Tower complex along Connecticut Avenue. It featured an unusual green Spanish-tile roof and was built three-stories high with stucco and limestone and had an interior composed completely of mahogany. It featured a ballroom measuring 44 by 67 feet on the third floor, and was built at a cost of $60,000. (Smithsonian.)

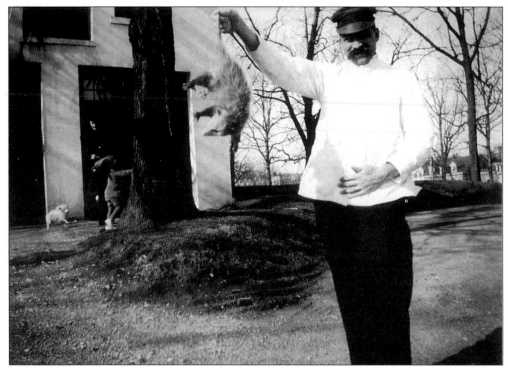

Harry Wardman's butler holds up a live opossum found on the lawn of his vast estate, demonstrating the rather rural nature of the surrounding land at the time the Wardmans were in residence. (HSW.)

Mrs. Harry Wardman of Washington, D.C. was a well-known socialite and served as a member of the Republican National Committee from the District of Columbia in 1924. While she was away in Paris in 1928 supervising the education of their daughter Helen, Harry Wardman gathered his servants to work for 48 hours straight to remove all of their mansion furnishings so that it could be promptly razed and shortly thereafter replaced with the Wardman Tower apartment building. The building remains on the site today as part of the Wardman Park hotel complex. (LOC.)

Two

ROCK CREEK PARK AND
THE NATIONAL ZOO

Like residents of any major metropolitan city, Washingtonians strive to escape the "hustle and bustle" of city life and relax in the great outdoors. Fortunate for Woodley Park residents, Rock Creek Park is at their doorstep, offering acres of unspoiled land that meanders through the northwest section of Washington.

Created in 1890 "for the benefit and enjoyment of the people of the United States," Rock Creek Park originates at the Potomac River and is accessible by several neighborhoods, including Georgetown, Foggy Bottom, Adams Morgan, Sixteenth Street Corridor, Cleveland Park, and, of course, Woodley Park. Once the home of the Algonquin Indians and a swimming venue for Civil War soldiers, Rock Creek Park is now a true city park and is a popular refuge for nature lovers, as well as those looking to enjoy soccer, hiking, bicycling, rollerblading, tennis, or horseback riding. Those who call Woodley Park home also enjoy meeting local artists at the Art Barn and attending summer concerts at The Carter Barron Amphitheater.

Rock Creek Park laid the foundation for future national parks and is the home to the Peirce-Klingle Mansion, Peirce Mill, the Battleground National Cemetery, Meridian Hill and, most notably, the National Zoological Park, which makes its home in the picturesque Rock Creek Valley and was one of the first zoos to be located in a spacious, landscaped setting.

Since the National Zoo's inception in 1889, Woodley Park residents, including those at the nearby Kennedy-Warren apartment building, have awakened to the sounds of lions growling, wolves howling, and other noises from their four-legged neighbors. Designed by the famed architectural landscape firm of Frederick Law Olmstead, who was also responsible for the design of Central Park and the United States Capitol Grounds, the National Zoo has evolved from a showcase of the country's exotic species to a leading conservation organization, public education pioneer, and scientific research site. Of course, adorable pandas, monkeys, and tigers are still the main attraction.

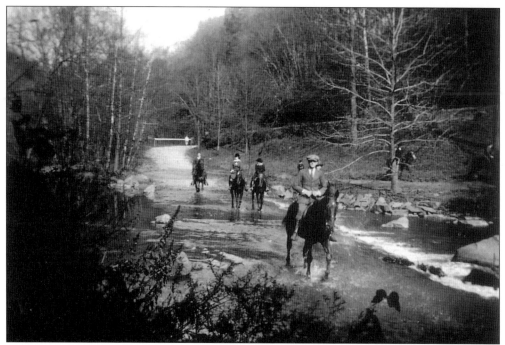

Horseback riding has always been popular in Rock Creek Park and remains so today. The genesis of Rock Creek Park dates back to 1866 when a Senate committee suggested finding a tract of land for the presidential mansion that had fresh air and clean water. (HSW.)

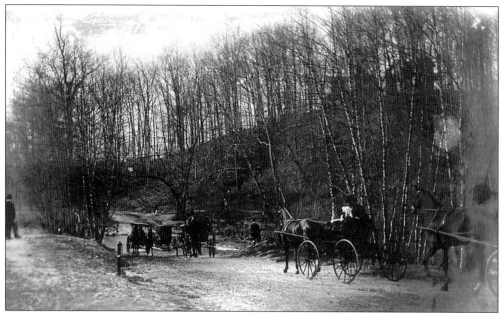

Horse and carriages make their way through Rock Creek Park in this vintage photograph. Unlike other great American parks designed in the 19th century, such as Central Park in New York (1856), Golden Gate Park in San Francisco (1870), and the Boston Metropolitan Park System (1878–1895), Rock Creek Park is a natural reserve within a heavily urbanized area. (HSW.)

This 1877 engraved view of Rock Creek Park was taken from a photograph by Jarvis and appeared in *Klein's Washington*. According to the Act of Incorporation of Washington of July 27, 1861, swimming in most of Washington's rivers, creeks, or canals was prohibited, with a fine of $2 per offense. Rock Creek, in addition to part of the Potomac River and Anacoastia, was one of the few areas where swimming was allowed. (LOC.)

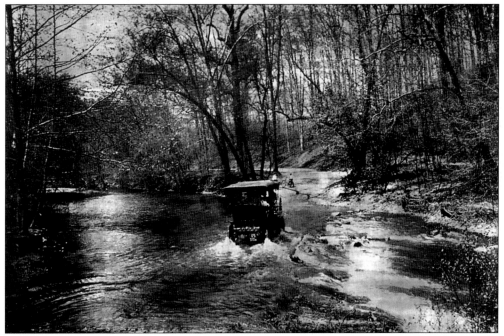

A Ford Model T, introduced in 1908, finds its way across a ford of Rock Creek Park near the National Zoo, c. 1915. Until 1966, when a series of bridges was completed, it was the only way across most of the park. (HSW.)

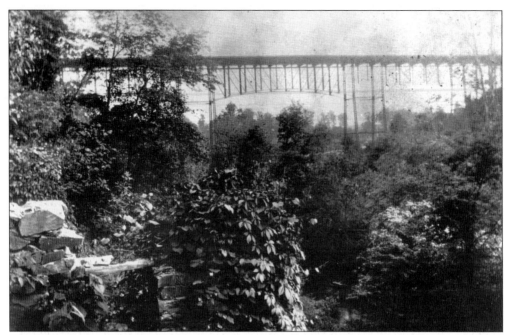

The Historic American Buildings Survey documented the ruins of Estes Mill in Rock Creek Park with the old iron Calvert Street Bridge in the background sometime before 1933, when construction began on the new Calvert Street Bridge. (HABS, LOC.)

This 1962 *Washington Star* photograph shows the construction of a 765-foot tunnel that allowed traffic to travel non-stop along Beach Drive from one end of Rock Creek to the other, bypassing the National Zoo. (Photograph by Ranny Routt.) (MLK.)

Created by an 1889 Act of Congress for "the advancement of science and the instruction and recreation of the people," the National Zoo became part of the Smithsonian Institution in 1890. In addition to the main 163-acre urban park in the Rock Creek Valley, the zoo also has a 3,200-acre Conservation and Research Center in Front Royal, Virginia. (LOC.)

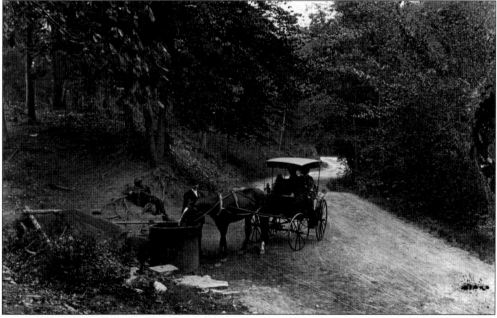

Pictured here is a horse and buggy at the National Zoological Park in the Rock Creek Valley. The zoo's spacious and picturesque area marked a significant departure from the 19th century philosophy of creating zoos in small areas. Because it was opened before New York's Zoological Park and Munich's Hellabrun Zoo, the National Zoo may have been the first zoo to be located in such a spacious setting. (MLK.)

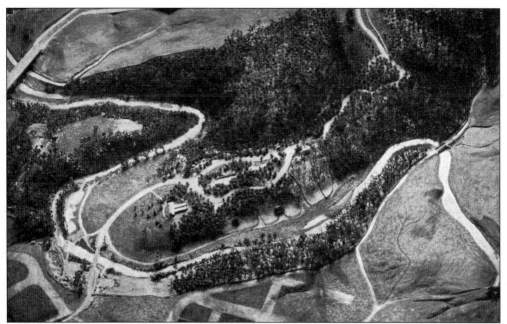

This 1893 photograph shows a birds-eye view of a model for the National Zoological Park. Plans for the zoo were drawn by three individuals—Samuel Langley, third secretary of the Smithsonian; William Temple Hornaday, a conservationist and head of the Smithsonian's vertebrate division; and Frederick Law Olmstead, a leading landscape architect who designed Central Park in New York. (MLK.)

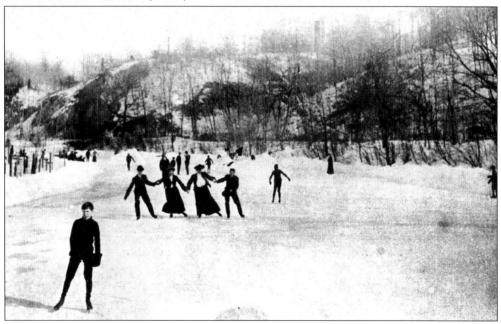

These Woodley Park residents were photographed enjoying a skating outing on the frozen duck pond of the National Zoo. Historians at the zoo indicate that the first recorded live animal gift to the nation occurred in 1785, when Charles III of Spain sent a "royal jackass" to George Washington while he resided at Mount Vernon. (LOC.)

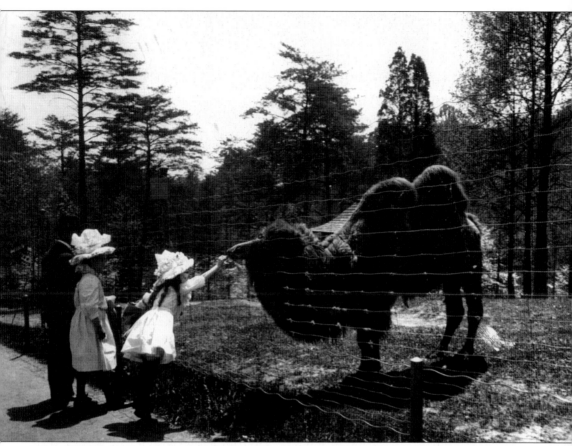

Victorian girls feed a camel at the National Zoo. Nicknamed the "ship of the desert" due to its common use as a transportation method in desert climates, camels at the National Zoo have been successfully bottle-fed by zookeepers when necessary. One such camel, which was orphaned after his mother died, was bottle-fed at a young age before making the transition to a vegetarian diet of hay and grain. (MLK.)

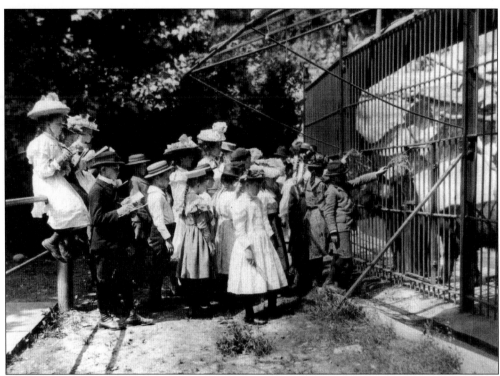

A group of public school children observe some of the many bears in the National Zoo (above) and a beaver dam (below) around 1900. The zoo has been at the forefront of striving to expand the public's knowledge of wildlife and the environment through public education programs aimed at teachers and school children. (Photographs by Frances Benjamin Johnston.) (LOC.)

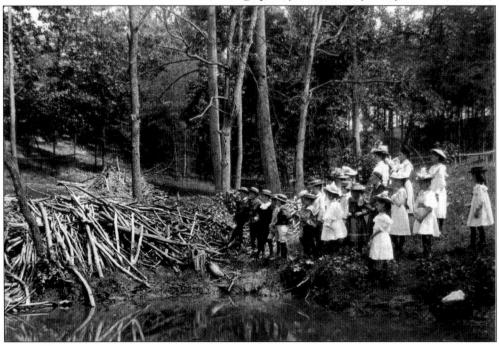

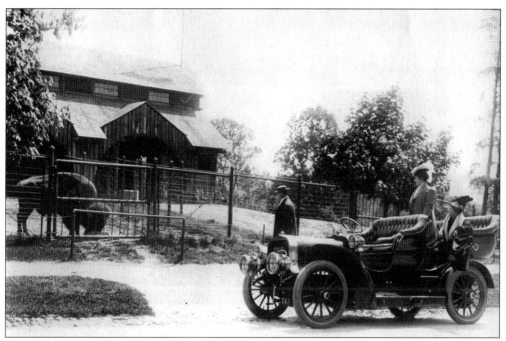

This 1906 image shows Victorian women admiring a buffalo at the National Zoo. In addition to exhibiting animals for the public to view, the National Zoo strove in the early years of its existence to create a refuge for buffalo and other animals that were quickly disappearing from the North American landscape. (LOC.)

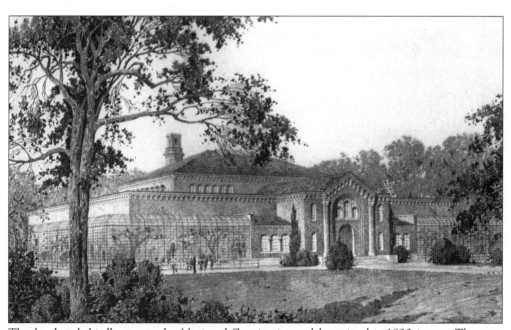

The landmark birdhouse at the National Zoo is pictured here in this 1930 image. The new birdhouse replaced the previous open large atrium design. Like many zoos in the early 1900s, the National Zoo focused on exhibiting as many exotic species as possible. (MLK.)

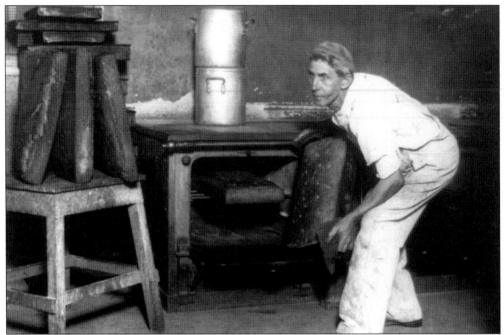

Charles C. Trevey is photographed here baking huge loaves of bread for the bears at the National Zoo in August of 1922. As part of the zoo's efforts to create a natural setting for its animals, natural rock quarries were installed to contain the bears, a plan that proved unsuccessful as some bears escaped. (LOC.)

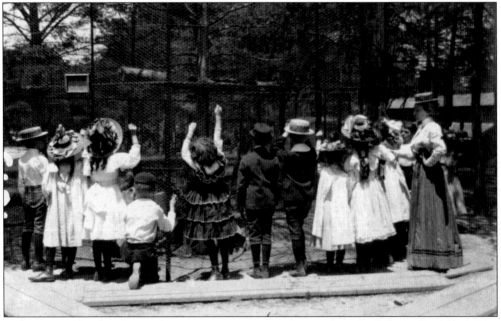

A group of public school children offer peanuts to animals at the National Zoo around 1899. This image demonstrates how easily accessible the animals were to the general public at that time, often within easy reach of small children's hands. (Photograph by Frances Benjamin Johnston.) (LOC.)

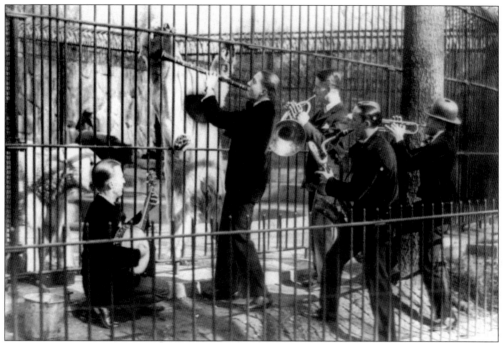

Five men play musical instruments in front of polar bears at the National Zoo (above), while a female joins the group to entertain the bears with dancing (below) in the 1920s. Despite Washington's long, humid summers, polar bears seem unaffected by the heat at the National Zoo. Past polar bears have resided at the zoo for more than 25 years without showing ill affects from the heat. (LOC.)

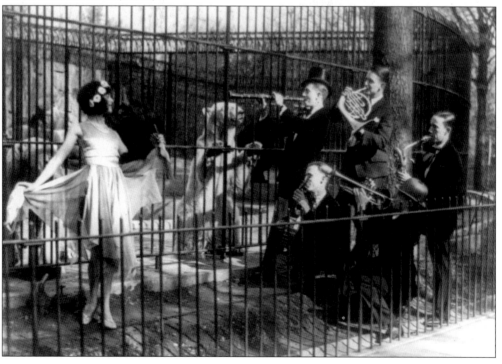

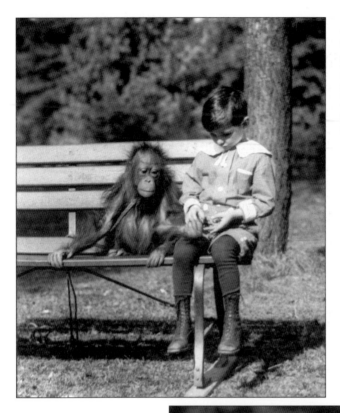

A young zoo visitor enjoys some fun time with an orangutan on a bench at the National Zoo. The present monkey house, the New Mammal House, is only one of two original zoo buildings that remain today. (LOC.)

A chimpanzee is seen here in May of 1926 seated at a table with bottle and glass at the National Zoo. The chimpanzees are known to be one of the easiest species for the zoo to exhibit due to their pleasant demeanor and friendly attitude toward spectators and keepers. (LOC)

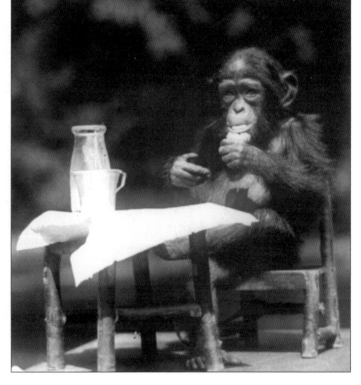

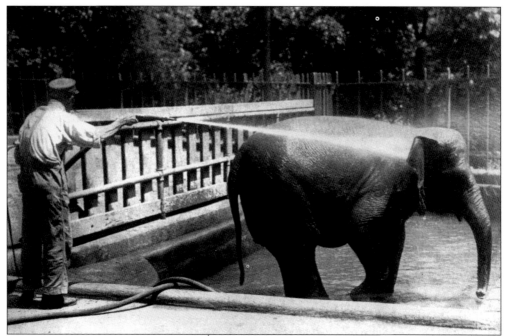

Kechil, a ten-year-old elephant that had been caught in Sumatran, is seen here being washed by his keeper in 1932. The elephant was known as the "bad boy" of the park, able to throw "with good aim rocks which have been tossed into his enclosure, and has been known to hit visitors on the head." (Author.)

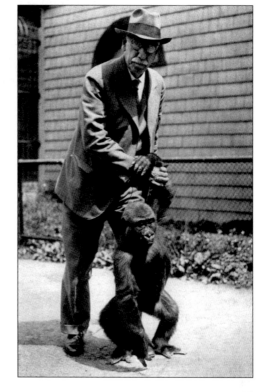

Seen here is William H. Blackburne, the first director of the National Zoo, who served in that capacity for over 40 years. Pictured with a baby gorilla named N'Gi, who had been captured in West Africa on January 17, 1928, Blackburne himself spent 12 years with the Barnum and Bailey Circus before his appointment as director. (Author.)

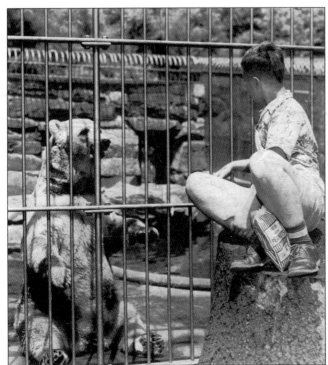

Tommy Smith feeds this hybrid bear, an offspring of a female Alaskan brown bear and a male polar bear—the first species of its kind ever born in capacity—in a September 1951 issue of *Pepconian* magazine. In the 1960s, the National Zoo created a zoological research division to study reproduction issues, especially of threatened and endangered species. (MLK.)

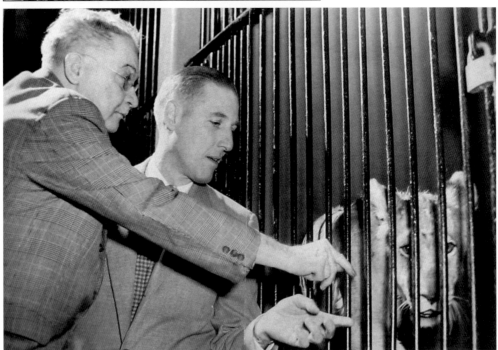

National Zoo Director Dr. William Mann is pictured with William J. Mileham in January 1951. The 1950s were an important decade for the National Zoo as the first full-time, permanent veterinarian was hired during a time period when the zoo began turning its focus to conservation efforts as more species began to decline. (MLK.)

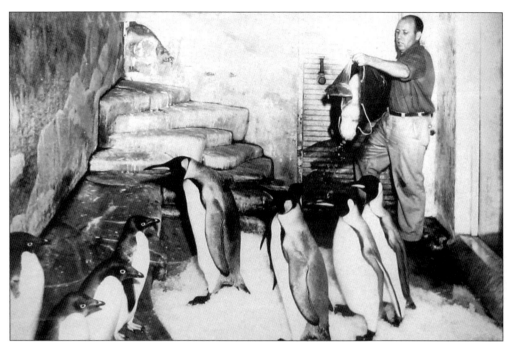

Bird-keeper Holmes Vourous gives the penguins some ice refreshment in this 1954 photograph. The late 1950s saw the creation of the Friends of the National Zoo (FONZ) in 1958, a nonprofit organization that persuaded Congress to fund the zoo solely through the Smithsonian. Previously the budget was split between the Smithsonian and the District of Columbia's appropriations. FONZ now boasts over 38,000 families in its membership. (MLK.)

Fred Bruehabler, official custodian of the zoo, is seen here with a lion cub in 1954. The National Zoo created natural settings complete with large grazing areas and placed animals in natural groupings instead of in individual cages. The lion house, also known as the Prinicipal House, is one of two original buildings that remains today. (MLK.)

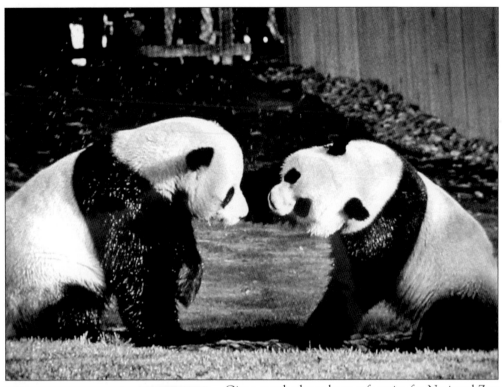

Giant pandas have been a favorite for National Zoo visitors for over 30 years. Hsing Hsing and Ling Ling came to the Zoo in 1972 as a gift from the People's Republic of China in response to President Richard Nixon's historic visit. During their time at the zoo, 70 million visitors came to see the panda pair. (MLK.)

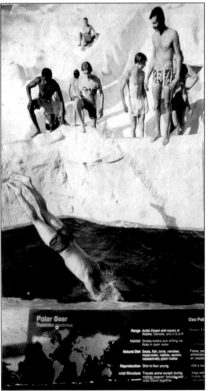

Some of the National Zoo staff members playfully enjoy a swim in the new 171,000 gallon pool within the polar bear enclosure upon its completion in August 1973, two weeks before the bears arrived. The polar bears continue to be a favorite for visitors today. (MLK.)

Three
IMPRESSIVE BRIDGES AND THE HOUSING BOOM

Woodley Park's landholding history began with a large teardrop-shaped piece of property belonging to Mrs. A.E. Kervand, which served as the heart of Woodley Park. By 1875, the Kervand property had been subdivided into 18 lots called "Woodley," the first suburban development northwest of Rock Creek. While previous development had been restricted to lands directly north of downtown Washington, Woodley Park, on the other hand, was located west of the Rock Creek Valley, a steep valley that was perceived as a natural barrier to westward development of the city.

Rock Creek Valley posed a serious obstacle for development. In 1887, the Engineer Commissioner reported no immediate plans to extend Connecticut Avenue northward beyond what is currently Columbia Road, citing Rock Creek and the hilly topography of the region as obstacles not worth tackling. Instead, Woodley Lane was seen as providing sufficient access, and it was decided that public money would instead replace Woodley Lane's old wooden bridge with a new iron truss bridge.

However, Connecticut was extended in 1890 due to the persistence of Sen. Francis G. Newlands and his business, the Chevy Chase Land Company. With the intent of establishing the suburb of Chevy Chase in Maryland and with all private efforts, Newlands and his agents began buying available land along a proposed extended Connecticut Avenue in 1888 to prepare a transportation artery to and from his new suburb. Through Newlands's efforts, two new iron truss bridges were constructed along Calvert Street and Connecticut Avenue to help fuel the northwestward development.

In 1907, the largest concrete bridge in the world was constructed and in 1931 was named after President William Howard Taft, who reportedly crossed the bridge daily. The Taft Bridge, commonly called "The Million Dollar Bridge," was significant as it opened up the Connecticut Avenue corridor north of Rock Creek for major development. Later, in 1935, another bridge pivotal to the development of Woodley Park was constructed: a replacement for the outdated Calvert Street Bridge, which would later be named the Duke Ellington Bridge.

The development of Woodley Park, as well as other neighboring areas, is undoubtedly a direct result of the construction of these bridges and the improved transportation methods that allowed motorists to cross into northwest Washington. Moreover, the subsequent housing boom between 1905 and 1929 in Woodley Park also directly correlates with the bridge construction. The string of 20th-century row houses and townhouses found today in Woodley Park began during this 25-year span and was highlighted by buildings constructed by notable architects and builders such as Clarke Waggaman, Harry Wardman, Arthur B. Heaton, George N. Ray, and the firms of W.C. & A.N. Miller and Middaugh & Shannon.

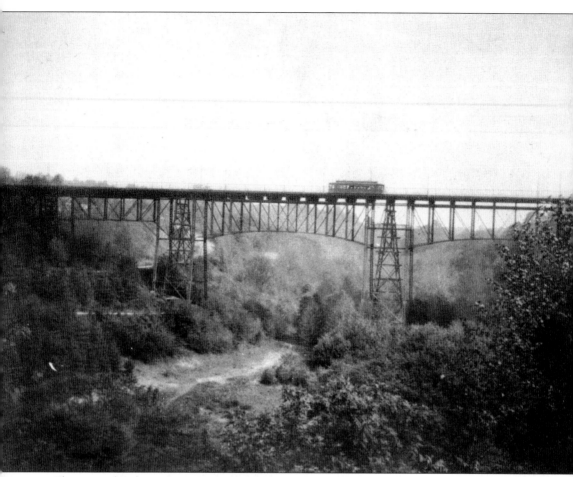

The original Calvert Street Bridge was built in 1891 for the Rock Creek Railway Company and is pictured here. The structure, built by the Edgemore Bridge Company, allowed for the continuation of the Rock Creek Railway line, which was fueled by the need for a streetcar to extend northwestward. After completion, the railway company turned the bridge over to the city government. (LOC.)

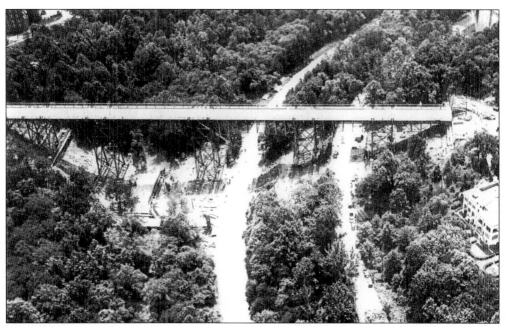

The original wrought-iron Calvert Street Bridge was 755 feet long and weighed 1,266 tons. Built for the Rock Creek Railway Company, it cost an estimated $70,000. (HSW.)

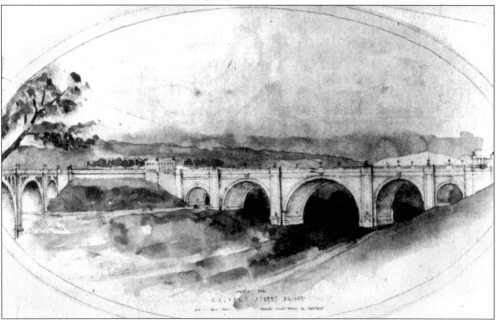

In 1917, District Commissioners hired local architect George Oakley Totten Jr. to design a new Calvert Street Bridge, and one of his designs is seen here. However, the Commission of Fine Arts (CFA) determined that Totten's design was too costly and ornate and feared that it would overshadow the nearby Connecticut Avenue Bridge. Totten fought the CFA, but the organization chose to entertain design proposals from other architects. Finally, in 1933, the CFA determined that the conditions in Rock Creek Valley had changed since Totten's original 1917 design and selected Paul Cret as chief designer with his new design in mind. (LOC.)

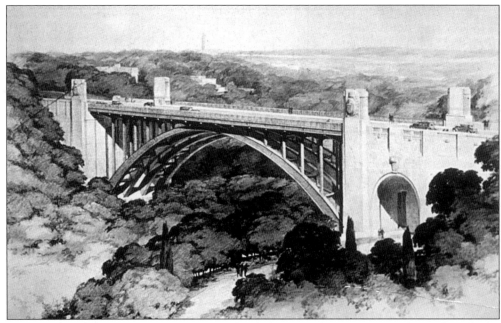

In January 1932, District Commissioners decided to use the engineering firm of Modjeski, Masters & Chase and architect Paul Cret's single-arch steel design for the new Calvert Street Bridge, shown here. However, in July 1933, District Commissioners changed their mind and opted for a masonry bridge with multiple arches. (HSW.)

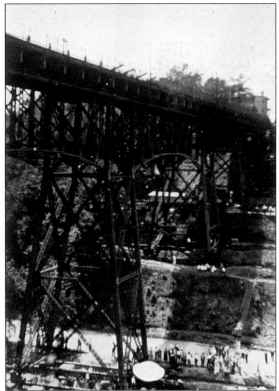

Fearing an inevitable collapse of the outdated Calvert Street wrought-iron bridge, plans were initiated to build a new bridge in the early 1930s. The original bridge was moved downstream on rollers powered by four horses. It was moved 80 feet in just 7 hours and 15 minutes. The old bridge was used as a detour for streetcars and automobiles during the construction of the new bridge. Once the new bridge was complete in 1935, the old bridge was demolished. (HSW.)

An unidentified group of men oversee the construction of the new Calvert Street Bridge, which was completed in 1935. The bridge's three arches are like those on other bridges across Rock Creek; however, the smooth, monochrome design of the Calvert Street Bridge façade varies greatly from the nearby Taft Bridge. The Calvert Street Bridge, later renamed the Duke Ellington Bridge, cost approximately $964,700 to construct. After almost a 20-year debate on the design, the engineering firm of Modjeski, Masters & Chase and architect Paul Cret were awarded the contract to build the new bridge. (HSW.)

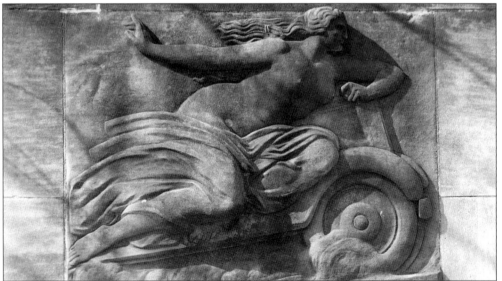

This 1930s image shows one of the four sculptural reliefs on the Calvert Street Bridge designed by sculptor Leon Hermant. This image of a woman leaning over a chassis was chosen as the symbol for the automobile to reflect the transformation to the speedy automobile. Hermant also designed reliefs to depict railroads, sailing, and air transportation. (Photograph by Jack Boucher.) (LOC.)

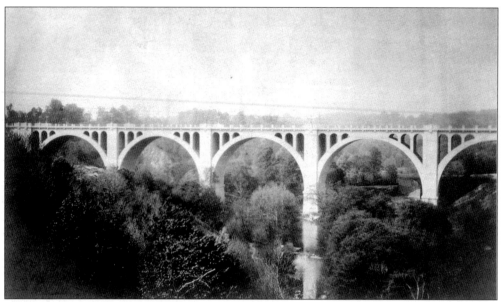

Here is a side view of the Taft Bridge as seen from Kalorama Triangle. The bridge was named after President William Howard Taft who reportedly crossed the bridge daily. It was significant because it opened up the Connecticut Avenue corridor north of Rock Creek for major development. (LOC.)

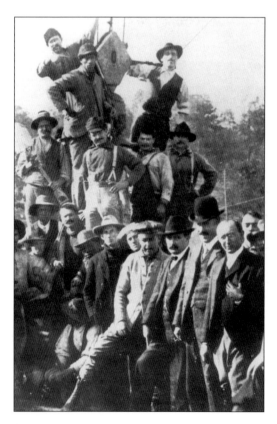

Workers on the Taft Bridge, designed by George S. Morrison and Edward Pearce Casey, pose for a photograph shortly before its completion in 1907. When the bridge opened that year, it was the largest concrete bridge in the world. It is commonly called the "Million Dollar Bridge" due to the enormous cost of its construction. In 1964, the bridge was designated as a Washington, D.C. historic landmark. (LOC.)

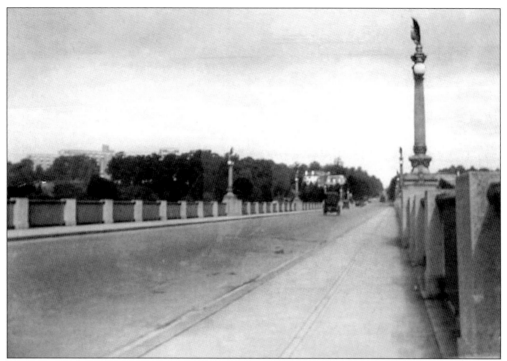

The Taft Bridge, completed in 1907, replaced Sen. Francis G. Newlands's original steel trestle bridge, which was completed in 1891 over Rock Creek and connected Connecticut Avenue to Calvert Street. (LOC.)

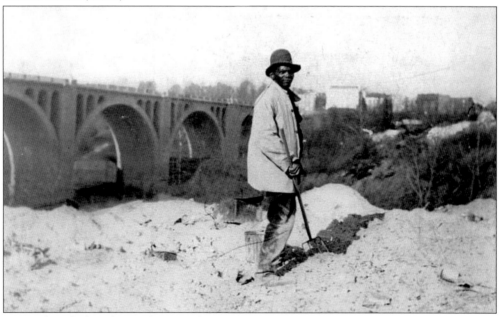

An unidentified worker picks up coal near the Taft Bridge. In addition to its impressive size, the Taft Bridge is easily identifiable by signature eagle lampposts on its sides. The lampposts were designed by Ernest Bairstow, whose decorative sculpting also can be seen on the Lincoln Memorial. (MLK.)

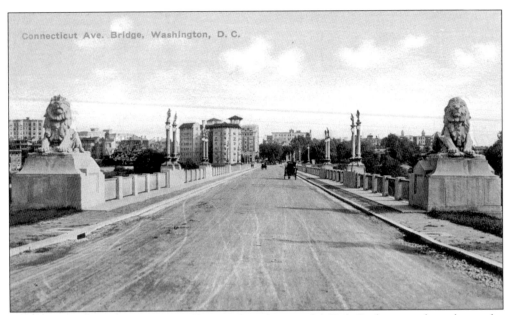

Connecticut Ave. Bridge, Washington, D. C.

In 1911 and 1934, proposals to add a streetcar line to the Taft Bridge were brought to the Commission on Fine Arts and the United States Congress. In 1911, the CFA rejected the proposal over aesthetic concerns. In 1934, the Capital Transit Company and the Public Utilities Commission proposed that the streetcar line on the Calvert Street Bridge be transferred to the Taft Bridge. In response, Congress introduced a resolution to "prevent the mutilation of the Taft Bridge," as it feared that the already congested route would allow for only one car on each side of the streetcar. Thus, the CFA rejected this proposal, too. (Author.)

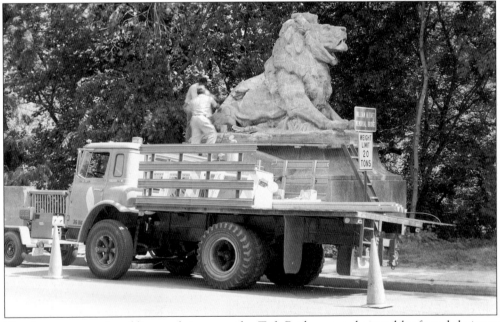

The famous two pairs of lion sculptures on the Taft Bridge were designed by famed designer Roland Perry. Placed at each end of the bridge, the lions were removed for restoration in 1985. However, they were eventually recreated. (Photograph by Jet Low.) (LOC.)

46

The Klingle Bridge, constructed between 1930 and 1932, was designed by Paul Cret with Modjeski, Masters & Chase serving as chief engineers—the same team that collaborated on the Calvert Street (Duke Ellington) Bridge. The single-arch steel span was deliberately simple so that it would not interfere with the picturesque landscape of Rock Creek Valley. (LOC.)

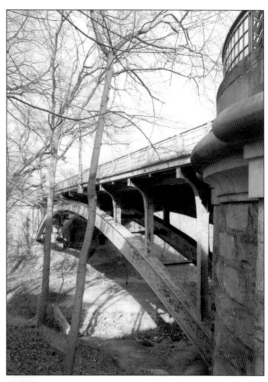

Eight stone urns topped by bronze-fitted lamps decorate the end posts of the Klingle Bridge. The urns were designed to resemble miniature lighthouses, while art deco detailing also was used for decoration. The bridge cost $458,951 to build; the original 1891 steel truss bridge cost $35,000. (LOC.)

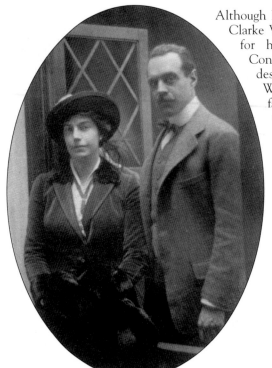

Although he had no formal training in architecture, Clarke Waggaman designed a large house in 1907 for himself and his wife Grace at 2600 Connecticut Avenue. He lived there while designing many large residences in Washington, including a later one for his family located at 2840 Woodland Drive, which they moved into in 1917. His first house has since been demolished. (LOC)

Only two years after its completion in 1917, architect Clarke Waggaman died unexpectedly at his "dream house" at 2840 Woodland Drive, seen here. He was 42. Twenty years earlier, Clarke's father, Thomas E. Waggaman, ran a real estate business and developed many properties in Woodley Park and Cleveland Park. (Author.)

Following his death in 1919, the Waggaman home at 2840 Woodland Drive was leased to the Russian government for use as its embassy. Waggaman also had designed homes at 2602, 2607, 2618, 2623, and 2627–29 Connecticut Avenue (which now serve commercial purposes), as well as homes along Massachusetts Avenue and Woodland Drive. (MLK.)

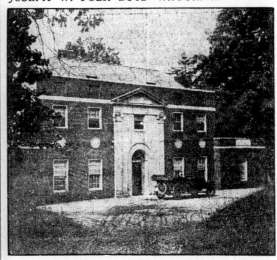

JOSEPH W. FOLK BUYS WAGGAMAN HOME.

Randall H. Hagner & Co. report the sale of the former home of the late Clarke Waggaman, at 2840 Woodland drive, Massachusetts Avenue Heights, to former Gov. Joseph W. Folk of Missouri. It is understood that the property, which includes one and a quarter acres of land, was held at $100,000.

The Waggaman home is one of the show places of Washington and reflects the artistry of the late Mr. Waggaman, who was a leading architect. The property is leased to the Russian embassy until October 1, after which extensive improvements will be made. Gov. Folk will make the premises his Washington home.

The home is of the Georgian type of architecture and contains twenty rooms. It is opposite the residence of Judge T. T. Ansberry, and overlooks Rock Creek Park.

Harry Wardman built a house for John Poole in the 2600 block of Woodley Road in 1908, as well as those located between 2712–48 and 2813–35 27th Street. Another of his houses was at 2272 Cathedral Avenue, seen here, built for Wardmen business partner Joe N. Thompson. All were designed by architect Albert H. Beers. (Author.)

According to historian Sally Berk in her 1989 thesis on Harry Wardman, the houses at 2606–2634 Garfield Street, which he had built in 1908, featured "the most eclectic façades and the most elaborate façade arrangement of any Wardman-built row." According to the 1914 *Boyd's Directory*, they were occupied by a senator, an official of the Treasury Department, businessmen, and government workers. (Author.)

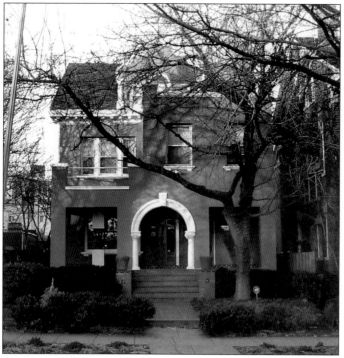

In 1911, prolific builder Harry Wardman had Frank Russell White design this house for attorney Alexander Wolf at 2651 Woodley Road, as well as a house next door at 2653. That same year, he built row houses at 2814–18 Connecticut Avenue. In 1913, Wardman built the two duplexes at 2657 and 2659 Woodley Road. (Author.)

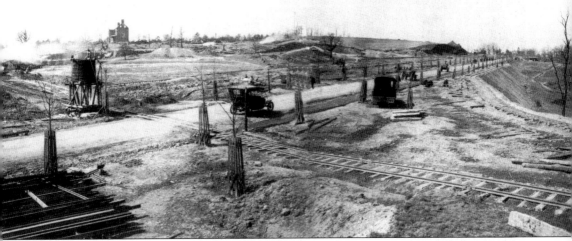

The section of Massachusetts Avenue near Wisconsin Avenue shows the rural nature of the area in 1911. To the right, Normanstone Drive and Woodland Drive would later occupy this area, both leading to the emerging suburb of Woodley Park. (LOC.)

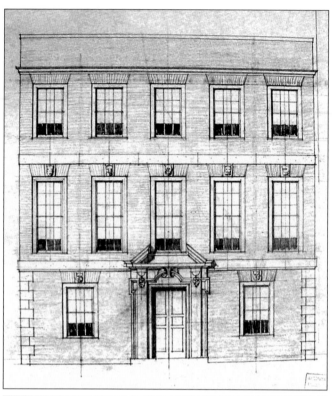

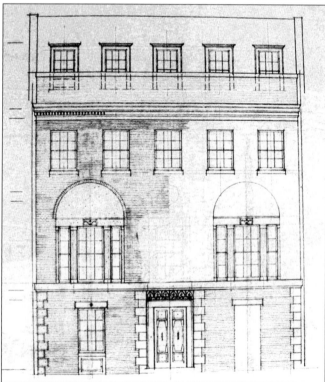

Commission numbered 196 of the Waggaman & Ray architectural firm was for this row house and medical office of Dr. James A. Cahill on Connecticut Avenue, near Calvert Street. These two potential designs were drawn between 1921 and 1922. (LOC.)

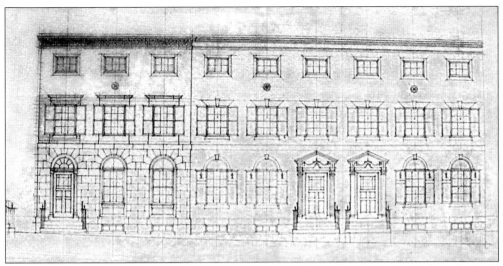

Architect Arthur B. Heaton provided the design shown above for a house in 1920 to be built by the Middaugh & Shannon development company from 2727 to 2737 Connecticut Avenue. The row of houses as they appear today is seen below. (Above, LOC; Below, Author.)

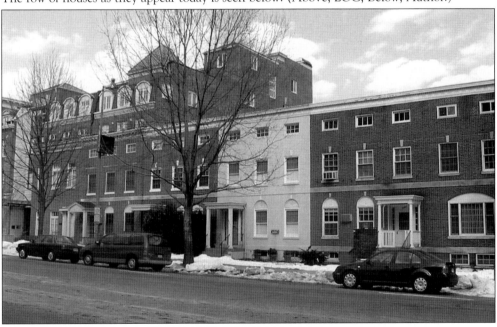

Harry Wardman had architect Mihran Mesrobian design what he coined as an "English Village" in Woodley Park. It was built beginning in 1923 along 34th Street and Klingle Road (seen here), and Cathedral Avenue and Cleveland Road. Additional homes, some designed in an English Tudor style, were built in 1924 along 29th and 34th Streets and Cleveland Avenue and Woodley Road. The proliferation of the automobile and the move to the suburbs gave rise to such "garden city" planning concepts. (Author.)

Construction continued in the English Village development the following year along 28th and 29th Streets, as well as Woodley and Cathedral Avenues, and in 1926 along 28th Street, Cortland Place, and Klingle Road. Inspired by post-medieval vernacular architecture found in many English towns, the final houses in the planned community were added in 1927 on 29th Street and Cortland Place. (Author.)

This advertisement from the *Trades Unionist* features a home at 3214 Woodley Road that was owned by the Electrical League of Washington and open to "show what real comfort there is in a correctly lighted and wired home." They planned on giving away the home to a child at the conclusion of a "home lighting essay contest." (Author.)

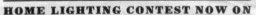
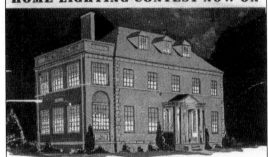

This cross-section and window detail drawing was completed by architect George Nicholas Ray for a house designed for Edward S. Perot at 2881 Woodland Drive. It was designed and built between 1925 and 1926. (LOC.)

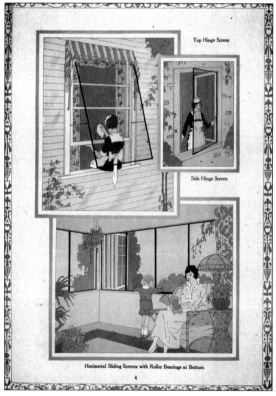

Architect G.N. Ray included these rather whimsical drawings of a screen's operation in a design for a house at 2881 Woodland Drive in 1925. The house was designed for Edward S. Perot, an investment banker. (LOC.)

This detail of the arches surrounding the garage and entrance at 2618 31st Street shows the fine crafted architectural elements that architect Arthur B. Heaton added in 1926 to the house, which was already under construction. They had come from the Henry Hobson Richardson–designed mansion at the corner of 16th and H Streets, built for Henry Adams in 1884. (Photograph by T. Luke Young.)

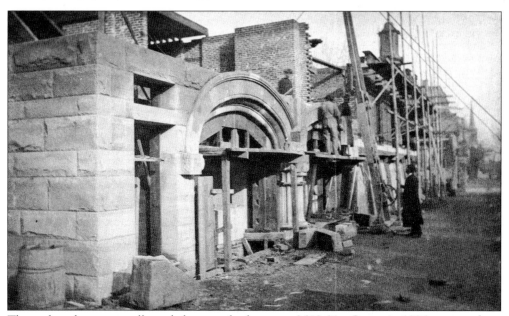

The arches that eventually ended up on the house at 2618 31st Street in 1926 are seen here under construction in 1884 at their original location along 16th Street, N.W. The owner of 2618 31st Street in 1930 was physician William C. Stirling and his wife, Margheritta. (LOC.)

This house at 3014 Woodland Drive was designed by Arthur Heaton and built in 1926 with a reused front door and a carved-stone surround that was originally on the John Hay house at 16th Street and H Street, N.W. Heaton served as an architect for Harry Wardman that year, designing the Capitol Garage on 13th Street and the Wardman Office building on K Street. (Photograph by T. Luke Young.)

The John Hay house, seen here with the front door later reused on 3014 Woodland Drive facing H Street, was adjoined to the Henry Adams house on 16th Street. Both were built simultaneously in 1884 and designed by Henry Hobson Richardson. Carl D. Ruth, a Washington correspondent for the Cleveland, Ohio *News*, and his wife, Cora, owned the house at 3014 Woodland Drive in 1930. They had moved there upon its completion in 1926 from a house on Mintwood Place, N.W. (LOC.)

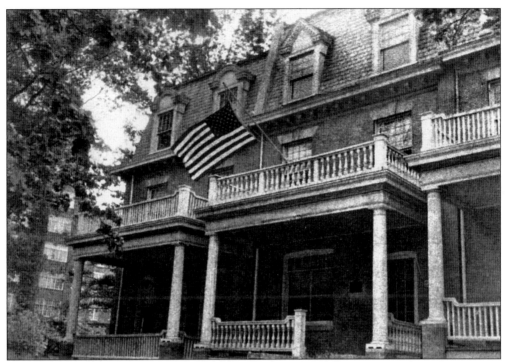

In 1926, St. Thomas Church purchased the house in the center of this photograph, located across the street from its chapel at 2702 28th Street, to serve as a school. The corner house at left (2700) was purchased the following year, as was 2706, bought in 1928. The unfortunate residents at 2704 lived for years in the middle of the church school complex before their house, too, was purchased and converted into the school buildings. (St. Thomas Church.)

This image, taken in 1930, shows the rural nature of Cathedral Avenue leading just outside Woodley Park toward the emerging suburb of Wesley Heights. (MLK.)

This image, shot in 1930, was taken looking south on 32nd Street near Woodland Drive when it was a rural road in a wooded setting. At that time only a handful of large houses dotted the landscape. (MLK.)

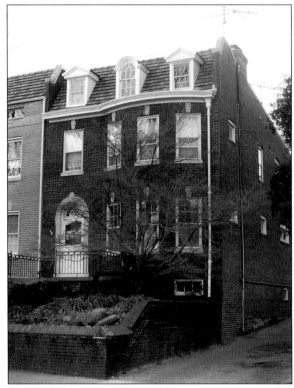

Alice Montague Warfield—better known as the mother of Wallis Warfield Spencer, who married King Edward VIII in 1936 six months after their scandalous relationship had forced him to abdicate the throne—also ran a boarding house at 2703 Woodley Road, which is pictured here, in the 1930s. (Author.)

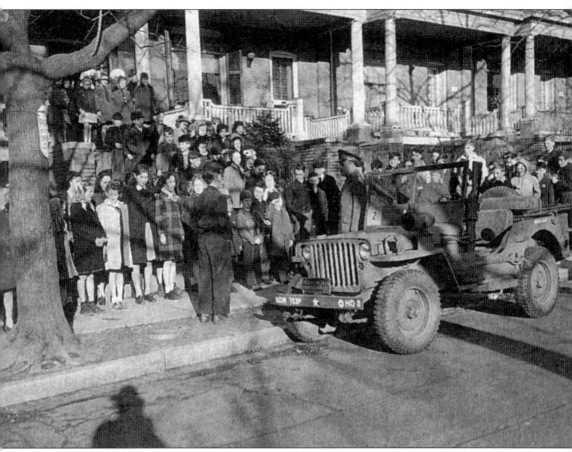

Many Woodley Park residents who were drafted benefited from war bond drives, such as this one held in 1944 in front of the row houses at 2700–2706 28th Street, which served as the school for St. Thomas Apostle Church. They were torn down in 1963. (St. Thomas Church.)

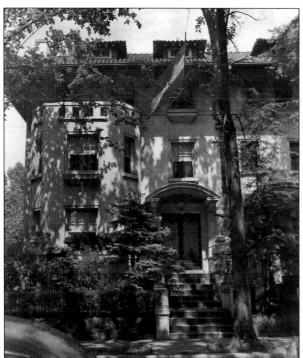

This picture of the house at 2611 Woodley Road was taken on July 1, 1945 when it served as the Embassy of Honduras, during the same year that nation became one of the founding members of the United Nations. (MLK.)

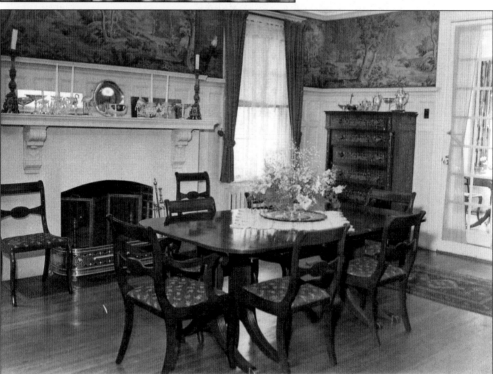

The dining room of 2611 Woodley Road was photographed as part of a story on the Embassy of Honduras that appeared in the *Washington Star* in 1945. Three years later, President-dictator Tiburcio Carias Andino resigned and free elections were held throughout the country. (MLK.)

The Embassy of Panama was located at 2601 29th Street when this image was taken in October of 1945. (MLK.)

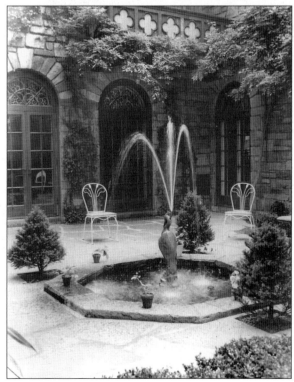

This elegant fountain was located on the patio of the Embassy of Panama at 2601 29th Street. That same year, women in Panama received the right to vote in elections for the first time. (MLK.)

Señora de Vallarino, wife of the ambassador Dr. Dom J.J. de Vallarino, was photographed by the *Washington Star* in 1945 while she resided at 2601 29th Street. Three years later, after severe protests, the United States announced withdrawal of troops from its wartime bases in Panama. (MLK.)

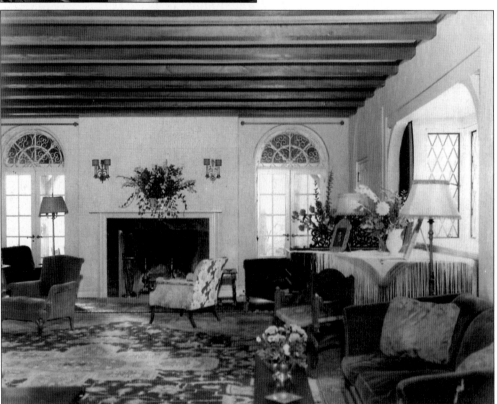

This rare interior image depicts the elegant living room of the Panamanian Embassy at 2601 29th Street. (MLK.)

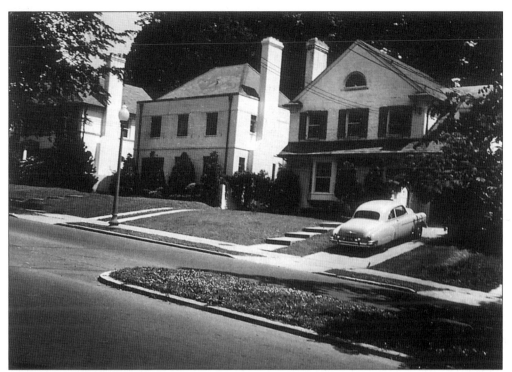

Photographer John Wymer took this image of the houses on Cleveland Avenue at 31st Street on June 17, 1950. In 1930, the house at 3100 had been owned by Pembroke and Paula Jones, while the one at 3102 was occupied by United States representative Alben T. Barkley of Kentucky. (HSW.)

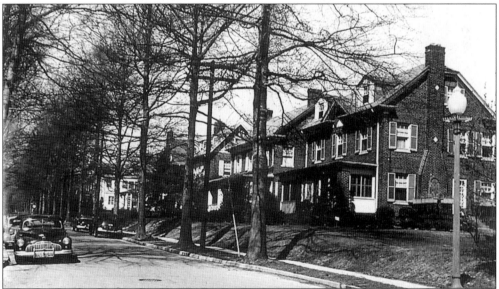

This row of houses along Cathedral Avenue west of Woodley Road was taken by photographer John Wymer on April 15, 1951. Earlier, in 1930, Colorado senator Lawrence Cowle Phipps resided in "Single Oak" on the southwest corner, while Claude A. Jones, an employee of the Bureau of Engineering, lived at 3104 Cathedral. (HSW.)

This house on Garfield Street at Woodland Place was captured by photographer John Wymer on April 15, 1951. (HSW.)

This elegant house at 3417 Woodley Road was photographed on April 15, 1951 by John Wymer. For the 1920s and 1930s, it was home to widow Annie M. Celephane. (HSW.)

The tennis courts that once were located on the corner of 34th Street and Woodley Road were photographed by John Wymer on April 15, 1951. (HSW.)

The Thomas J. Fisher Company placed this advertisement for the subdivision of 144 acres in Massachusetts Avenue Heights in 1912, which was offered for sale between 50 cents and $1.50 per square foot. Trustees of the company had apparently contracted $750,000 for "macadam roads, bridle paths, granolithic sidewalks, sewers, water, and other modern utilities." (Author.)

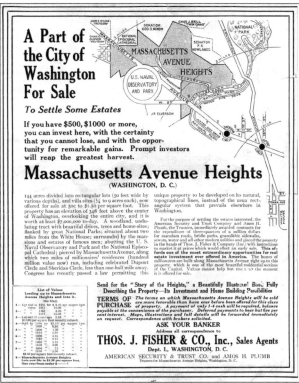

This view looking north on Woodland Drive near 29th Street was taken in 1913, shortly after the road was paved, and shows the extreme rural nature of the area long before the myriad homes that line the street today were built. (MLK.)

Clarke Waggaman designed this house at 2941 Massachusetts Avenue for Mrs. L.F. Day. It was purchased in 1917 by Joseph P. Davis, who traveled to Paris with Woodrow Wilson for the negotiation of the Treaty of Versailles. (Author.)

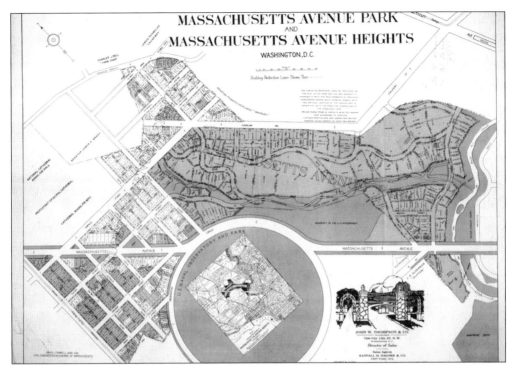

This map of the proposed "Massachusetts Avenue Park" and "Massachusetts Avenue Heights" was drawn in 1917 by architect Clarke Waggaman. It was part of his extended plan that surrounded his own home at 2840 Woodland Drive, which was just in its design stage. (LOC.)

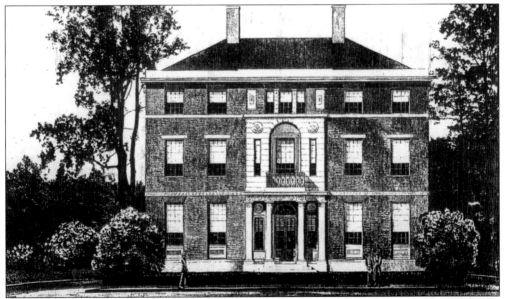

In 1917, architect Clarke Waggaman provided the designs for this house at 2929 Massachusetts Avenue for Col. and Mrs. John Williams. Maie Williams was the mother-in-law of wealthy Dupont Circle resident Joseph Leiter. Built at a cost of $35,000, the house was later owned by the Count and Countess Szechenyi from Hungary. The Countess was the former Gladys Moore Vanderbilt, daughter of Cornelius Vanderbilt. (Smithsonian.)

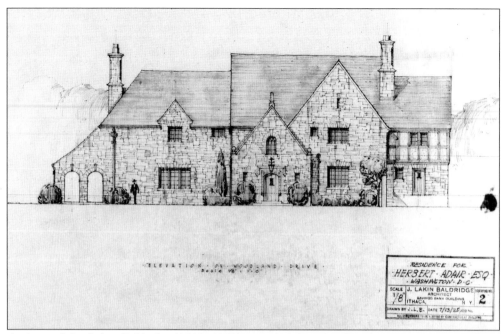

Architect John Lakin Baldridge (1892–1968) provided this plan for a house at 2860 Woodland Drive in 1925 for owner Herbert Adair. Adair was president of the Southern Company whose office was later located in the Shoreham Hotel. (LOC.)

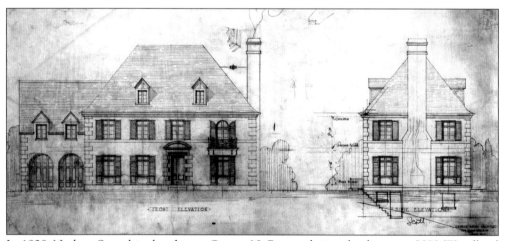

In 1928, Nathan Scott hired architect George N. Ray to design this house at 2833 Woodland Drive at McGill Terrace for Nathan B. Scott, then an assistant treasurer at the Continental Trust Company. (LOC.)

These architectural
drawings for a
housing
development
bordered by
Woodland Avenue,
Cleveland Avenue,
and 31st Place were
completed between
1927 and 1928 by
Arthur B. Heaton
for the Shannon &
Luchs development
firm. Heaton began
the practice of
architecture in
1900 when he
worked as a
draftsman for
architect Frederick
B. Pyle. (LOC.)

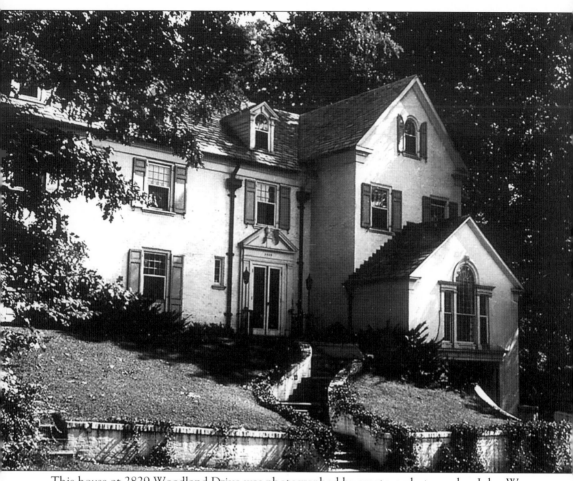

This house at 2829 Woodland Drive was photographed by amateur photographer John Wymer on September 17, 1949. In 1939, it was home to Neal R. Howard. (HSW.)

Four

CHURCHES, COMMERCIAL AREAS, AND GRAND HOTELS

The housing boom in the early 1920s that followed the construction of major bridges spanning Rock Creek Valley also led to the growth of religious-based and commercial structures in Woodley Park.

The early settlement of Woodley Park brought the construction of many large apartment buildings and individual homes, resulting in a need for new places of worship. In 1909, Fr. Thomas A. Walsh, who was assistant pastor at St. Paul's Church at 15th and V Streets, met with Cardinal Gibbons of Baltimore to discuss locating a new Catholic parish in Woodley Park. Three years later, in 1912, land was purchased to house the current St. Thomas Church at 27th Street and Woodley Road.

Although it was founded well before the housing boom of the 1920s, St. Alban's Episcopal Church also responded to the influx of new residents in Woodley Park. The church, which was founded in 1851 on Mount Alban, added a gothic tower and bay in the 1920s to enlarge the church. In 1924, St. Alban's completely encased the original building in stone.

The 1920s also saw a major commercial boom in Woodley Park, primarily along the neighborhood's main thoroughfare, Connecticut Avenue. Small, local businesses lined Connecticut Avenue, combined with the beautiful single-family row houses and townhouses. Today, many of the single-family homes remain. However, the commercial area is now dominated by tall apartment buildings and smaller commercial buildings in converted residential structures.

Woodley Park's expansion, as well as major tourist attractions such as the National Zoo, also created a need for adequate lodging for tourists, as well as grand ballrooms to provide entertainment options for the city's residents. Hence, two significant hotels made their way to Woodley Park—the Shoreham Hotel and the Wardman Hotel.

Designed by Joseph Abel, the Shoreham Hotel was originally opened for apartment rentals in 1931 before it was an extravagant hotel between 1950 and 1955. The famed Shoreham, currently called the Omni Shoreham, has been a favorite for politicians and entertainers, including Gary Cooper, Judy Garland, Bob Hope, Frank Sinatra, and even Marilyn Monroe. Noted for its grand art deco lobby and the Blue Room nightclub, the hotel is located on a site originally owned by Harry Wardman, whose original dream of five apartment buildings on the property was never realized.

Wardman made a name for himself in another Woodley Park hotel venture with the 1,200-room Wardman Hotel on Woodley Road, built in 1916. Despite criticism from people who doubted that no one would go to a hotel in "the country," the hotel brought the city to Woodley Park, providing prosperity and publicity for the quiet wooded area. Wardman Tower, an addition built in 1928 on the grounds of Wardman's old home, is the only building of the original hotel left.

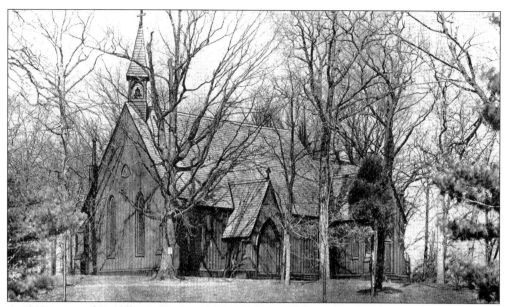

A 1902 image of St. Alban's Episcopal Church is seen here. The church was founded in 1851 and is geographically part of the National Cathedral grounds, although not officially tied to the Cathedral. The church is located on Mount Alban, which was purchased by Joseph Nourse in 1813. When his daughter, Phoebe, died in 1850, she left $40 in gold for the creation of a free church on Mount Alban. (MLK.)

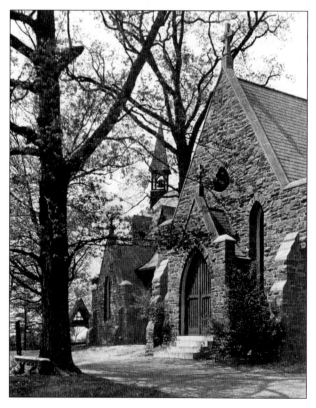

The original building of St. Alban's Church and its additions were encased in stone in 1924, as seen in this image. A gothic tower and bay were added to improve the appearance and enlarge the church. (Author.)

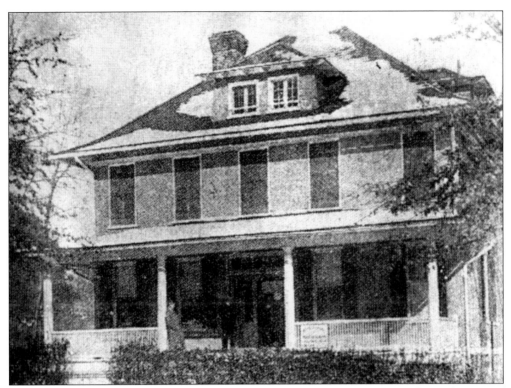

With a multitude of homes and small apartments established in the early settlement of Woodley Park, the Catholic Church began preparations for establishing a new parish named St. Thomas. In 1912, Fr. Thomas A. Walsh rented this house, known as the Stonestreet Mansion, at 2737 Cathedral Avenue for use as a temporary sanctuary. It later would serve as the Embassy of the Republic of Benin. (St. Thomas Church.)

Father Walsh, seen here, served as the first pastor of the St. Thomas Apostle Church in Woodley Park from 1909 to 1936. It was he who had met with Cardinal Gibbons of Baltimore in 1909 (while serving as an assistant pastor of St. Paul's church at 15th and V Streets) and had suggested locating a new parish in Woodley Park. (St. Thomas Church.)

This cream-colored clapboard chapel was built under the direction of Father Walsh at the present site of the St. Thomas Apostle Church rectory, shortly after the land was purchased at a cost of $16,750 on February 9, 1912. (St. Thomas Church.)

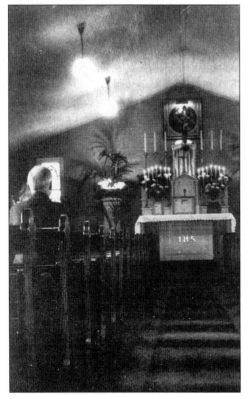

This image, taken in 1920, shows the warm interior of the St. Thomas chapel, which began serving parishioners eight years earlier. Early church records indicated that it was called both St. Paul's mission and the St. Thomas chapel. Many parishioners in the years to come were residents of nearby apartments and visitors of nearby hotels. (St. Thomas Church.)

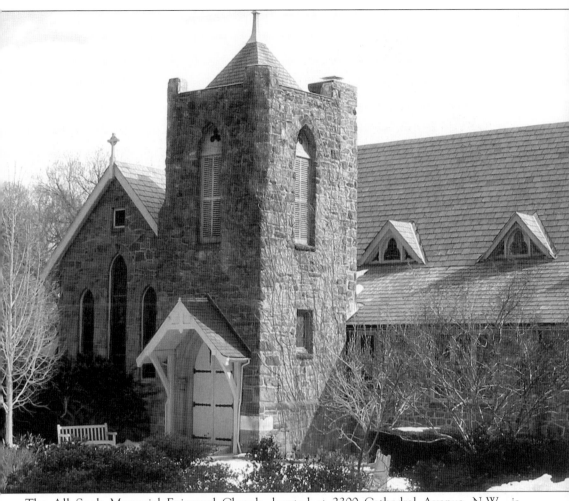

The All Souls Memorial Episcopal Church, located at 2300 Cathedral Avenue, N.W., is composed of a 1923 enlargement of the original church, which was built in 1914 and had a seating capacity of 230. Built as a memorial to the church's founder's son, James MacBride Sterrett Jr, who had died at the age of 17, the church was commonly called "The Little Memorial Church" before it was officially named "All Souls Memorial Church." The vision of the church was well stated in an early sermon after All Souls became a parish of the Diocese of Washington: "This is to be neither a broad church nor a narrow church, neither a high church now a low church, but a church of All Souls." (Author.)

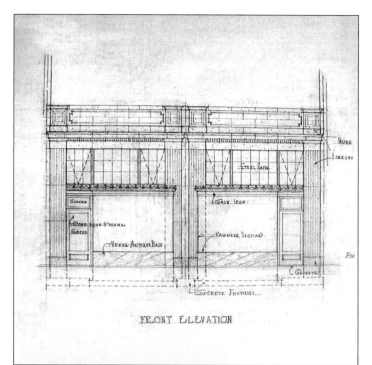

Architect George N. Ray provided these working drawings for two stores to be built by David J. Dunigan in 1927. They were located at 2609–2611 Connecticut Avenue. (LOC.)

Amateur photographer John Wymer captured a portion of the commercial district of the west side of Connecticut Avenue on September 17, 1949. The Wardman Tower apartment building can be seen in the top portion of the background. (HSW.)

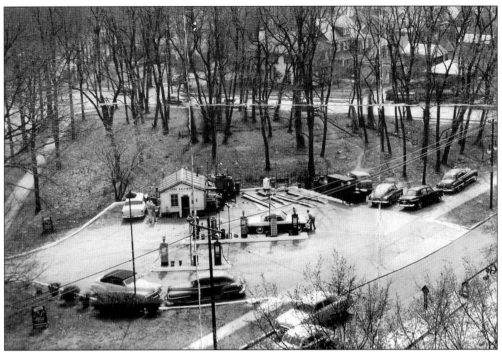

The Lord Baltimore AMOCO gas station, seen here in these two 1950 photographs, was once located in a wooded area near Wisconsin and Massachusetts Avenues and was the center of a neighborhood controversy beginning in 1950. Its existence was constantly challenged by the ever-changing zoning regulations. Shortly thereafter, the National Capitol Planning Commission acquired it and created a neighborhood park on the site. (MLK.)

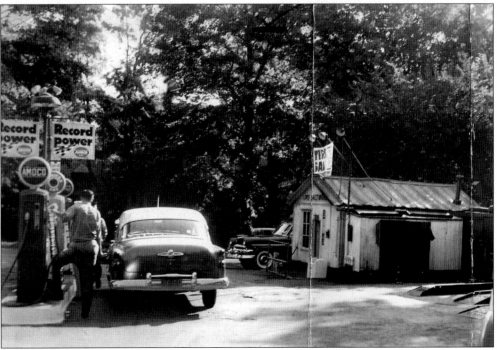

On June 17, 1950, amateur photographer John Wymer photographed this segment of Connecticut Avenue north of Woodley Road in Woodley Park. Today, Connecticut Avenue is lined primarily by tall apartment buildings and smaller commercial buildings; however, single-family residences still remain along Connecticut Avenue. (HSW.)

The Calvert Loop on the Capitol Transit Car Line, pictured here in 1948, served as the destination point where many Woodley Park residents could have exited to cross the Calvert Street Bridge. After the close of the streetcar system in Washington, streetcars were sold by O. Roy Chalk, the owner of the transit system, to Serbia and Montenegro (formally Yugoslavia) and are still running in downtown Belgrade. (HSW.)

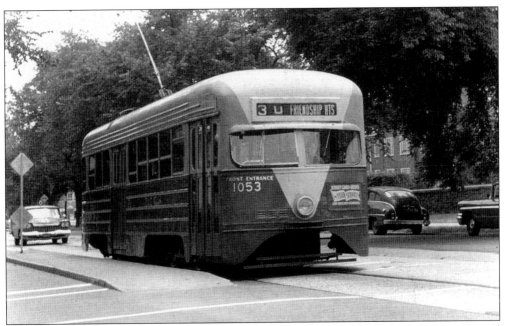

The late 1950s initiated the end of the streetcar system in Washington, D.C. This Capitol Transit Car No. 1051 was pictured on Wisconsin Avenue near the Washington National Cathedral. In the wee hours of Sunday, January 28, 1962, Capitol Transit Car No. 766 entered the Navy Yard Car Barn for the last time, and Washington's streetcars became history. (LOC.)

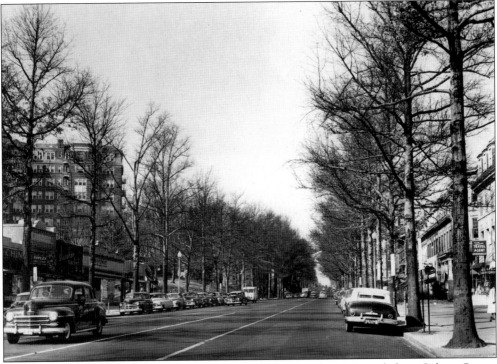

This 1952 *Washington Star* photograph depicts Connecticut Avenue north from Calvert Street, when many former residences had been converted to a variety of commercial uses. (MLK.)

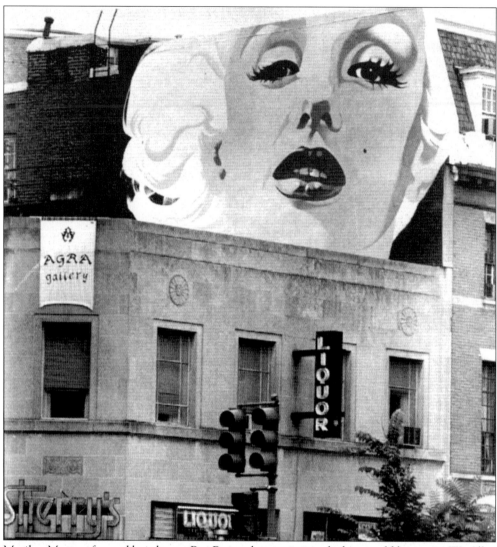

Marilyn Monroe fan and hairdresser Roi Barnard commissioned what would become a Woodley Park icon in 1982 when this mural of the famous celebrity was painted on the side of a building by John Bailey. High gloss, red enamel lips, and pieces of mirror in the eyes have made the creation almost lifelike to the thousands of passing motorists and residents ever since. (Author.)

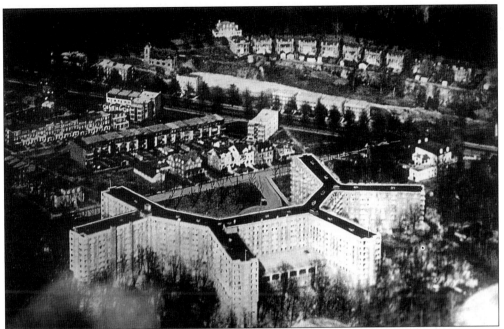

Harry Wardman constructed the 1,200-room Wardman Hotel along Woodley Road beginning in 1916, despite many local critics who said the location was not suitable for a hotel. It was designed by Frank Russell White and modeled after the Homestead Resort in Virginia, Wardman's favorite resort where he enjoyed many rounds of golf. Wardman's mansion can be seen to the right of the massive building. (HSW.)

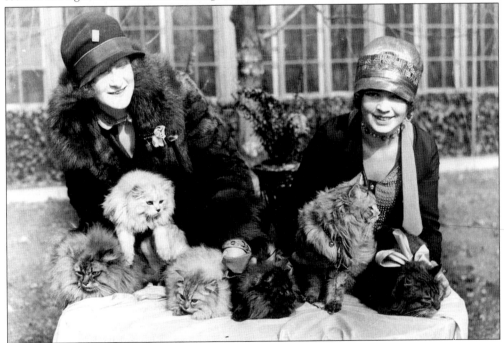

The Washington cat show was held at the Wardman Park Hotel throughout the 1920s. Edna B. Doughty and Louise Grogan are pictured here with their extravagant Persian cats. (LOC.)

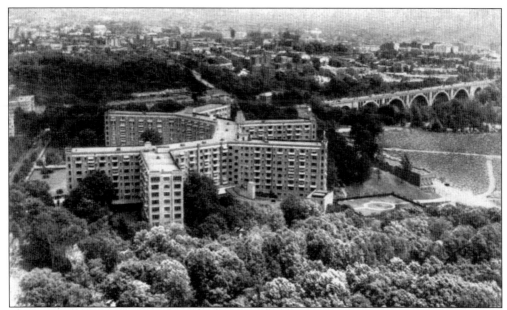

When he announced his plans to build the 1,200-room hotel, Washingtonians dubbed it "Wardman's Folly" because they thought no one would go to a hotel in what was then considered the countryside. Instead, the hotel provided prosperity and publicity for the quiet wooded area. Wardman Tower, a hotel addition built in 1928 on the grounds of Wardman's old home, is the only building of the original hotel left. (MLK.)

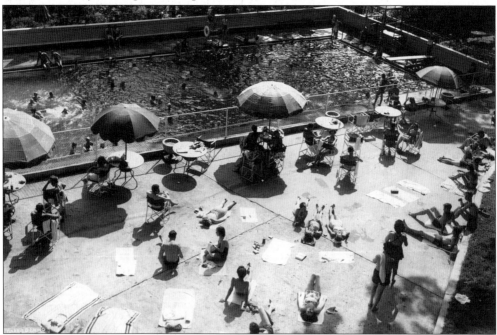

This festive pool scene at the Wardman Park Hotel was photographed on June 30, 1947. Inside the hotel that year, the first televised broadcast of *Meet the Press* took place in the Wardman Tower, where it continued to be televised for decades. Its moderator, Lawrence Spivak, was a Tower resident. (MLK.)

This June 8, 1948 pool scene at the Wardman Park Hotel shows Floren Harper with several suitors. In the early days of television, NBC and other television stations broadcast many programs at the hotel, including *The Camel News Caravan*, *The Today Show* (Frank Blair segments), and *The Arthur Murray Dance Program*. (MLK.)

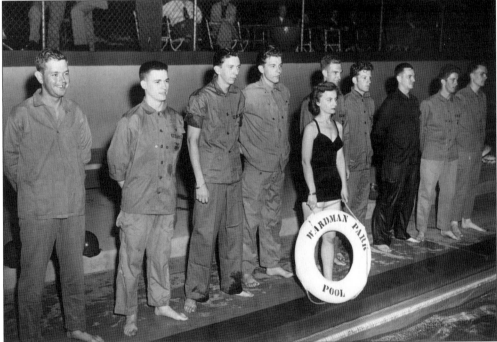

Marine Reserve Sgt. Charlotte Foltze stands by with a lifesaver at the Wardman Park Hotel pool, while more than 50 members of the 5th Marine Reserves learned how to swim with their clothes on. This training exercise took place on June 17, 1949 as United States Marine Corps Brig. Gen. Merwin H. Silverthorne and other brass looked on. (MLK.)

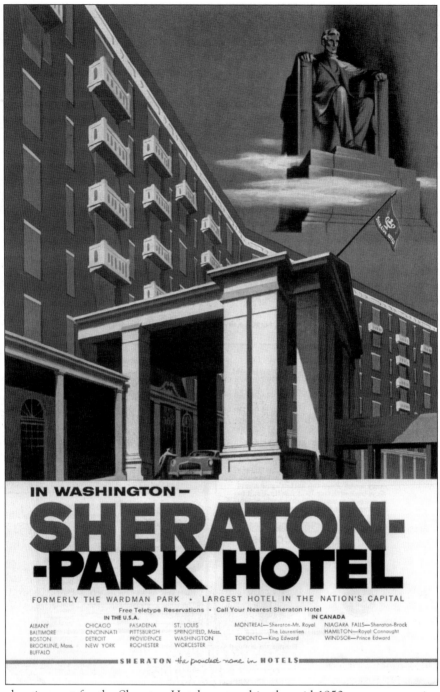

IN WASHINGTON –

SHERATON-
-PARK HOTEL

FORMERLY THE WARDMAN PARK • LARGEST HOTEL IN THE NATION'S CAPITAL

Free Teletype Reservations • Call Your Nearest Sheraton Hotel

IN THE U.S.A.

ALBANY	CHICAGO	PASADENA	ST. LOUIS	MONTREAL—Sheraton-Mt. Royal	NIAGARA FALLS—Sheraton-Brock
BALTIMORE	CINCINNATI	PITTSBURGH	SPRINGFIELD, Mass.	The Laurentien	HAMILTON—Royal Connaught
BOSTON	DETROIT	PROVIDENCE	WASHINGTON	TORONTO—King Edward	WINDSOR—Prince Edward
BROOKLINE, Mass.	NEW YORK	ROCHESTER	WORCESTER		
BUFFALO					

IN CANADA

SHERATON *the proudest name in* HOTELS

This advertisement for the Sheraton Hotel appeared in the mid-1950s to announce its name change from the old Wardman Park Hotel. Since its opening, the facilities have been used for 11 presidential inaugural balls, with one notable exception: upon becoming president after Nixon's resignation, Gerald Ford chose not to celebrate the somber occasion. Nixon actually used the Wardman Tower during his first unsuccessful bid for presidency against Kennedy, and in a peculiar coincidence, jurors during the Watergate trial were housed in the tower. (Author.)

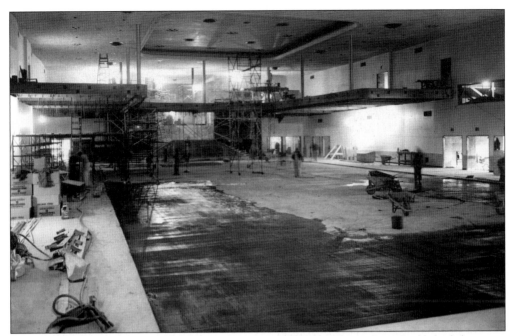

The ballroom of the newly constructed Sheraton Park Hotel was photographed while it was under construction on May 3, 1955. The Sheraton Corporation had purchased the hotel and apartment property in 1953 and renamed it the Sheraton Park Hotel. (MLK.)

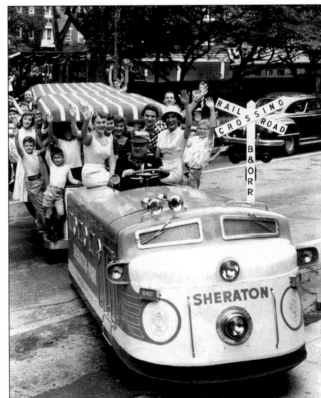

Kurt Smith, general manager of the Sheraton Park Hotel, takes control of the hotel's miniature locomotive for its first trip around the hotel. A full load of guests boarded the train for a ride around the hotel's 16-acre grounds when this picture was taken for the July 9, 1956 edition of the *Washington Star*. (MLK.)

Beginning in May of 1958, the female office help at the Sheraton Park Hotel started working out during their lunch hour. Pictured in the back row, from left to right, are Maybritt Graffius, Pat Meredith, and Barbara Norton. In the front row, from left to right, are Pat McAndrew, Margie Abell, Inge Koopmann, and Hilda Wolf. (MLK.)

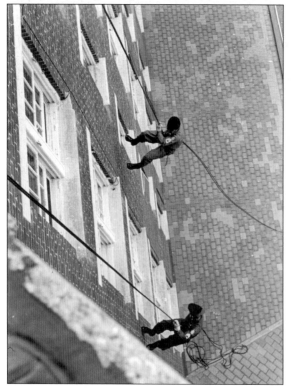

Soldiers are shown repelling down the side of the Sheraton Park Hotel in a training exercise on October 3, 1962. Part of an Army Special Forces group, the group included Sgt. Jack Jennings and Sgt. Thomas Butrim. (MLK.)

Miss Joan Vermett, a 20-year-old Miss Washington contestant from Arlington, Virginia, and Miss Ray Heath, a 20-year-old resident of southeast Washington, enjoy the pool on their lunch hour in the 1960s. They were photographed floating in the middle of the pool on an innovative "floating veranda" made of a newly developed product by the Dow Chemical Company named Styrofoam. (MLK.)

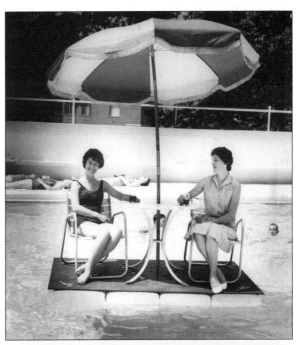

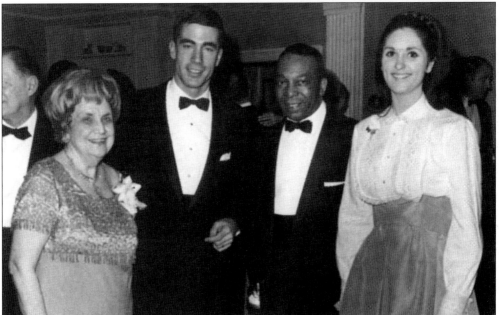

Wardman Tower was home to numerous famous residents, including Perle Mesta, shown on the left at her apartment party c. 1968. With her are guests Charles Robb, future governor of Virginia; Washington mayor Walter Washington; and Lynda Bird Johnson Robb. Mesta elevated dinner parties from mere social gatherings to lavish soirees that became the places to be seen and to mingle with other movers and shakers. More presidents, vice presidents, and cabinet members lived in Wardman Tower than any other Washington apartment house. They preferred this building because of its excellent hotel service in combination with spacious apartments. (Smithsonian.)

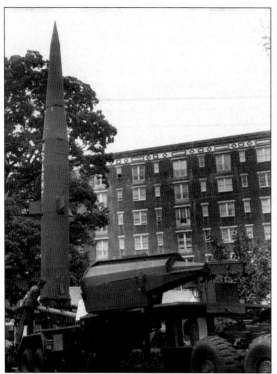

Cold War–era Pershing Missiles were displayed in front of the Sheraton Park Hotel on October 13, 1969. Before the United State's entry into World War II, espionage and intrigue enveloped the historic hotel with a beguiling British spy named Cynthia, who operated out of the facility as she spied on the French Vichy Embassy. Cloaked in the darkness of night, she would visit her lover, an embassy employee whom she had compromised, and steal top-secret documents. She would then transport them back to the hotel and photograph them in a lab she had set up in her room. (MLK.)

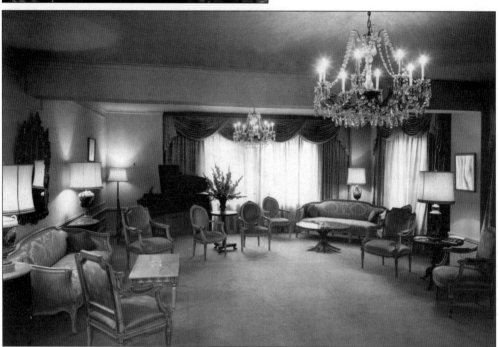

Seen here is Vice President Spiro Agnew and Mrs. Agnew's suite, shortly after Agnew became Vice President, at the Sheraton Park Hotel as it looked on February 7, 1969 when it was temporarily occupied by the Lyndon Johnson family. The Johnsons remained there until their new Spring Valley home was redecorated. (MLK.)

Richard F. Shore, the Sheraton Park Hotel security man, is seen here making his rounds through the building in 1977. (MLK.)

A public sale of the Sheraton Park Hotel furnishings took place on June 27, 1979. In 1980, the Sheraton Washington Hotel replaced the Sheraton Park Hotel, connecting the landmark Wardman Tower, the Park Tower, and the Center Tower convention/exhibit area. Marriott International later took over management of the property, renaming the hotel the Marriott Wardman Park Hotel. (MLK.)

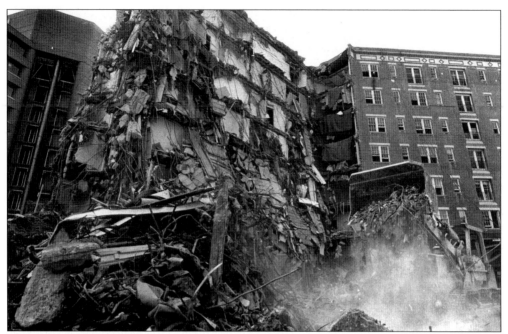

Demolition of the Sheraton Park Hotel's main building was documented in this photograph dated September 4, 1979. On the left can be seen the new Sheraton Washington Hotel, which was by then 75 percent complete. (Photograph for the *Washington Star* by Roy Lustig.) (MLK.)

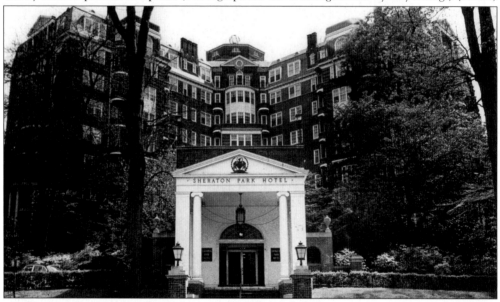

As Washington's preeminent convention hotel, the 1,338-room Marriott Wardman Park Hotel is the largest hotel in the Washington, D.C. metropolitan area and the eighth-largest hotel in the United States. Throughout its history, however, it has been the home to numerous nationally known figures including President Hoover, President Eisenhower, and President Johnson; Vice President Charles Curtis, Vice President Henry Wallace, and Vice President Spiro Agnew; Chief Justices Frederick M. Vinson and Earl Warren; Senators Charles Robb, Barry Goldwater, and Robert Dole; and even Hollywood legend Marlene Dietrich. (MLK.)

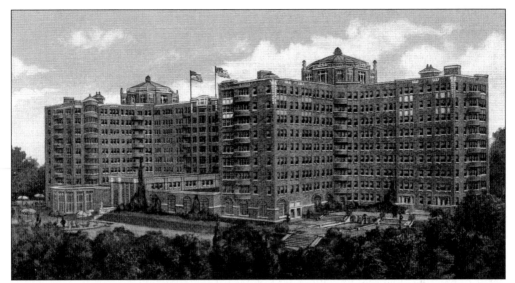

A postcard is seen here of the Shoreham Hotel, which was originally built as an apartment building by developer Harry Bralove. The land was originally owned by Harry Wardman, who had envisioned five apartment buildings and a garage on 13 landscaped acres. However, his son-in-law, Edmund Rheem, was unable to secure financing for the $5 million project and attempts to reduce the plan to a $300,000 project also failed. (Author.)

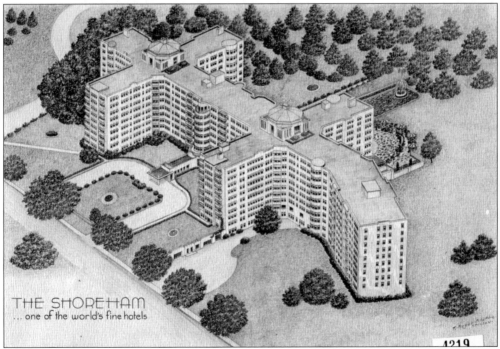

THE SHOREHAM
... one of the world's fine hotels

Designed by Joseph Abel, the Shoreham Hotel originally opened as rental apartments in 1931 before it was an extravagant hotel between 1950 and 1955. In addition to being a favorite of politicians, the Shoreham has hosted the famous and powerful, including Gary Cooper, Marilyn Monroe, and President Harry Truman, who held a weekly poker game at there. (Pencil drawing from *Washington, D.C. The Nation's Capitol*, 1953.) (MLK.)

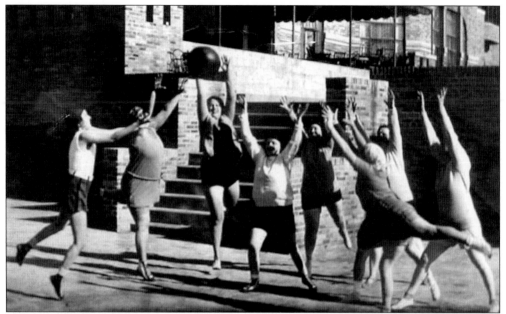

Prominent Washington society women are seen here on November 27, 1931 participating in the popular medicine ball classes held daily at the Shoreham Hotel. The classes' popularity was fueled in part by President Hoover's famous "Medicine Ball Cabinet." (LOC.)

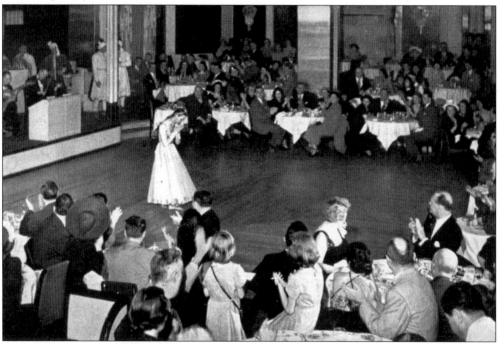

Beatrice Kraft takes a Hindu bow for patrons of the Shoreham's tony Blue Room. The elegant Shoreham Hotel is an important part of Washington's history, as it was the site where President John F. Kennedy courted his wife, Jacqueline. The Omni Shoreham Hotel, its current name, boasts the most ballrooms of any hotel in Washington, D.C., a total of 7 ballrooms ranging from 6,000 square feet to 18,000 square feet. (LOC.)

The main lobby of the Shoreham Hotel is shown here as it looked in 1954. The elegant art deco lobby features powerful arches and beautiful chandeliers, in addition to a picturesque view of Rock Creek Park. The hotel also featured Bob Hope, Frank Sinatra, and Judy Garland in the famous Blue Room nightclub. (MLK.)

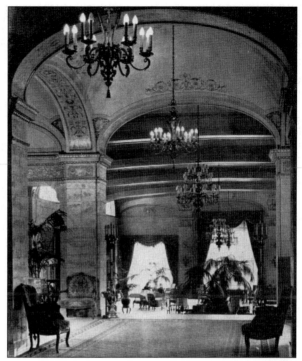

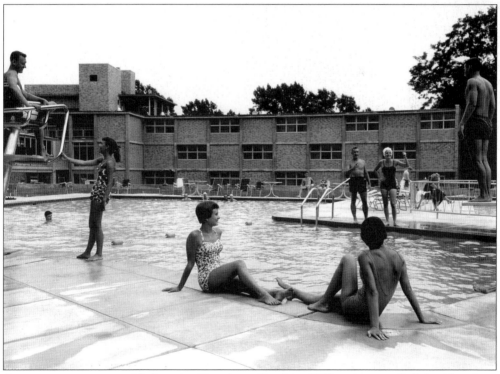

A new west wing was added to the Shoreham Hotel in 1959 and was called the Shoreham Motor Inn, which connected to the original hotel via the breezeway pictured to the left. Here, hotel guests enjoy relaxing poolside in July of 1959. (MLK.)

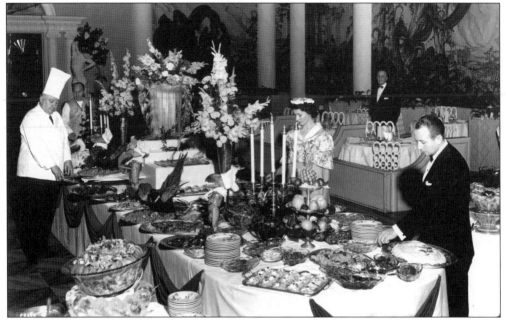

The Shoreham Hotel buffet was a popular nightly event at the Shoreham's Palladian Room, where dinners cost $3. Here, Executive Chef Eddie Dziura (left) arranges a special spread for the travel writers on July 8, 1959 to celebrate the opening of the new Shoreham Motor Inn addition. (MLK.)

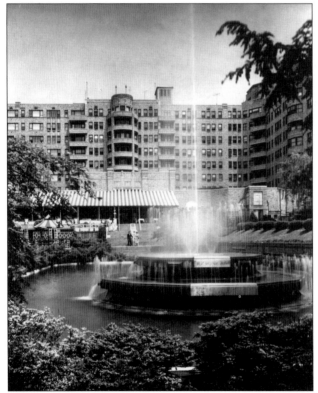

The fountain at the Shoreham Hotel, pictured here on July 8, 1959, served as a landmark for the hotel, especially in the evening, when the fountain produced a water extravaganza, including synchronized water sprays and colored lights. The beautiful sight was the perfect background for evening dinners on the famed terrace. (MLK.)

Five

INTRODUCTION OF
APARTMENT BUILDINGS

During the 1920s, 1930s, and early 1940s, the population density in Woodley Park increased with the construction of many apartment buildings. Woodley Park underwent a significant transformation due the continuous construction of massive yet elegant apartment buildings that forever changed the landscape of a once sleepy neighborhood.

Spurred by the construction of the Taft Bridge in 1907 and the subsequent housing boom of the 1920s, Washingtonians began to take notice of Woodley Park with its growing commercial area and proximity to such attractions as Rock Creek Park, the National Zoo, and the Washington Cathedral. To meet the needs of this newfound popularity, prominent architects and developers took the initiative to construct several large apartment buildings that are illustrated in this chapter.

Mansions on Connecticut Avenue was billed as the "world's largest apartment group" when it was constructed by Harry Wardman in 1920. The enormous structure stretched one-third of a mile along Connecticut Avenue and obtained the nickname, "A City Within Itself" due to its size and 2,700 residents.

The early 1930s saw the construction of three additional apartment buildings in Woodley Park as the neighborhood continued to attempt to sustain the population boom in the area. The Westchester was built in 1930 by developer Gustave Ring, and although the Great Depression cancelled plans for three additional buildings in the complex, the Westchester remained the largest apartment building in Washington until the arrival of the Woodner in 1951. The Great Depression also adversely affected the fate of the Kennedy-Warren's co-developer, Edgar Kennedy. The Kennedy-Warren, designed by Joseph Younger, was never completed due to financial circumstances and the subsequent bankruptcy of Kennedy in 1931. However, plans began in 2002 to complete Younger's original design.

The Delano, built in 1941, was one of more than 400 apartment buildings in Washington designed by George T. Santmyers. Another landmark apartment building is the magnificent Wardman Tower, which was covered in the previous chapter due to its close association with the Wardman Park Hotel.

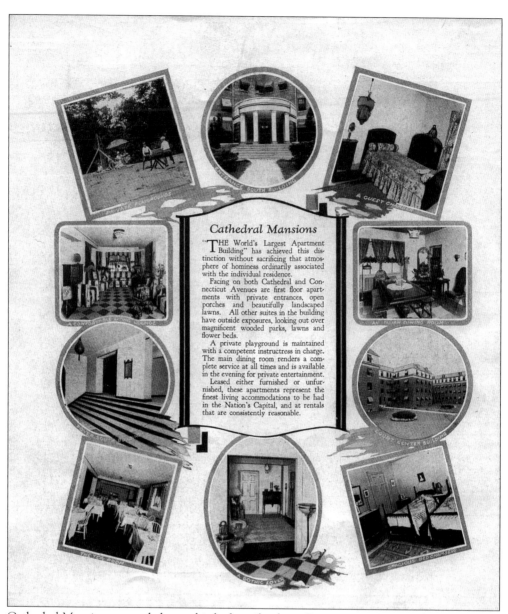

Cathedral Mansions

"THE World's Largest Apartment Building" has achieved this distinction without sacrificing that atmosphere of hominess ordinarily associated with the individual residence.

Facing on both Cathedral and Connecticut Avenues are first floor apartments with private entrances, open porches and beautifully landscaped lawns. All other suites in the building have outside exposures, looking out over magnificent wooded parks, lawns and flower beds.

A private playground is maintained with a competent instructress in charge. The main dining room renders a complete service at all times and is available in the evening for private entertainment.

Leased either furnished or unfurnished, these apartments represent the finest living accommodations to be had in the Nation's Capital, and at rentals that are consistently reasonable.

Cathedral Mansions extended one-third of a mile along Connecticut Avenue from Cathedral Avenue to Klingle Road and offered picturesque views of Rock Creek Park and the National Zoological Park. (MLK.)

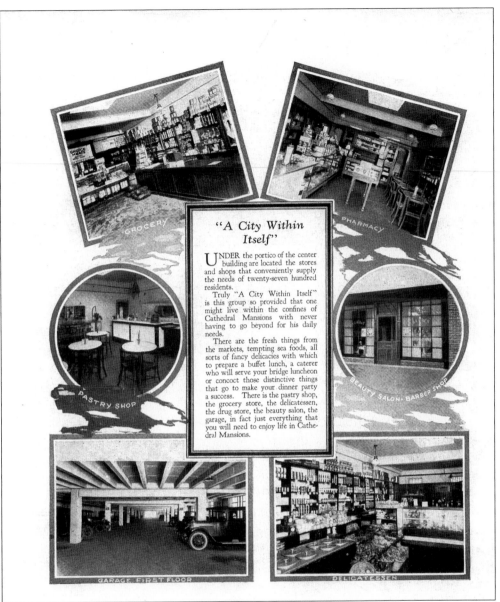

"A City Within Itself"

UNDER the portico of the center building are located the stores and shops that conveniently supply the needs of twenty-seven hundred residents.

Truly "A City Within Itself" is this group so provided that one might live within the confines of Cathedral Mansions with never having to go beyond for his daily needs.

There are the fresh things from the markets, tempting sea foods, all sorts of fancy delicacies with which to prepare a buffet lunch, a caterer who will serve your bridge luncheon or concoct those distinctive things that go to make your dinner party a success. There is the pastry shop, the grocery store, the delicatessen, the drug store, the beauty salon, the garage, in fact just everything that you will need to enjoy life in Cathedral Mansions.

Cathedral Mansions offered transportation facilities to and from the city center via a bus service with a real parlor car, "a real smoking compartment," and a streetcar for transportation between the apartment buildings. Built as the "world's largest apartment group," 2,700 residents lived at Cathedral Mansions in the 1920s. Due to its large size and bevy of services, the apartments were billed as "A City Within Itself." (MLK.)

This image shows Cathedral Mansions apartments at 3000 Cathedral Avenue, which was built in 1923 by Harry Wardman, one of the most prolific and influential developers of residential property in the history of Washington, D.C. (HSW.)

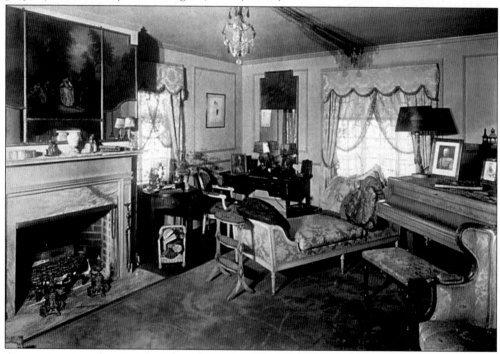

A rare interior photograph, taken between 1924 and 1930, of a residence at Cathedral Mansions shows the elegant nature of apartment homes. This apartment was owned by Mrs. Alfred Church, whose son-in-law, Harold Rayner, was Gen. John Pershing's aide in World War II and a White House aide to President Woodrow Wilson. (HSW.)

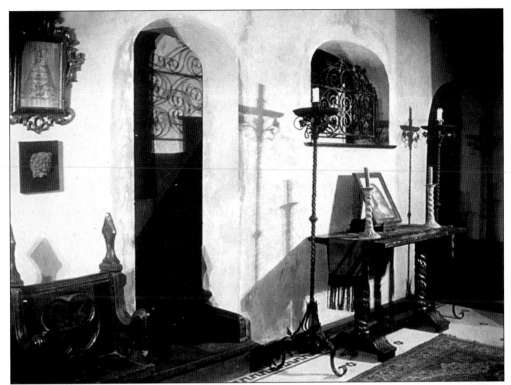

This 1920s image shows the interior of a spacious Cathedral Mansions apartment located at 3000 Connecticut Avenue, N.W., which was designated as a Washington, D.C. historic landmark in 1989. It was listed in the National Register of Historic Places in 1994. (HSW.)

The apartment building at 2722 Connecticut Avenue was constructed by Harry Wardman in 1915. Just five years later, he built the Glenbrook Apartment building, seen here, at Connecticut Avenue and Garfield Street. Architect Eugene Waggaman designed an apartment building for him that same year at 2659 Connecticut Avenue. (Author.)

Developer Harry Wardman constructed quite a number of apartment buildings in 1920, including those at 2700, 2726, and 2854 Connecticut Avenue, as well as the Parris and Governor apartment buildings at 2827–31 28th Street, seen here. In 1922, Wardman constructed the apartment buildings at 2900 and 3100 Connecticut Avenue, and in 1936, he constructed apartment buildings at 2701 and 2715 Cortland Place for the D.C. Development Company. That same year, he built an apartment building at 2760 Devonshire Place, designed by Mihran Mesrobian. (Author.)

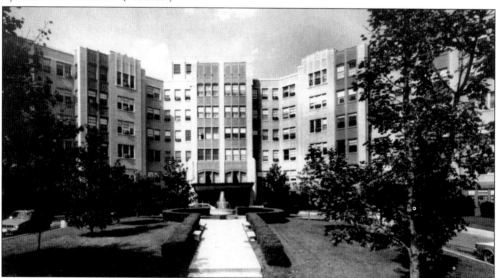

The Woodley Park Towers apartment complex was designed by architect Louis T. Rouleau Sr. in 1929 and built at 2737 Devonshire Place. When the complex opened in 1930, it consisted of 163 apartments: 78 one-bedrooms, 68 two-bedrooms, 5 three-bedrooms, and 12 efficiencies. (Author.)

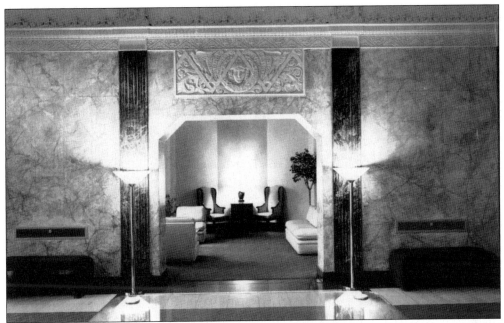

Architect Louis Rouleau designed the Woodley Park Towers in an art deco style, with Aztec motifs, as seen here in the public parlor. He also designed the building with six entrances and six elevators (eliminating the need for long walks down corridors), as well as parking for 65 cars on a two-level garage. (Smithsonian.)

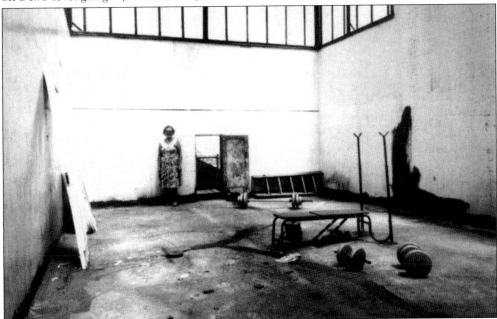

The art deco apartment building known as "2929 Connecticut Avenue" was opened in 1937. It was designed by the architectural firm of Dillon and Abel for owner Henry Jawish and Gustave Ring, who insisted on having a handball court built into the rooftop deck area, seen here in a dilapidated state in 1975. The 96-unit building also featured a large restaurant facing a courtyard on the basement level. (Smithsonian.)

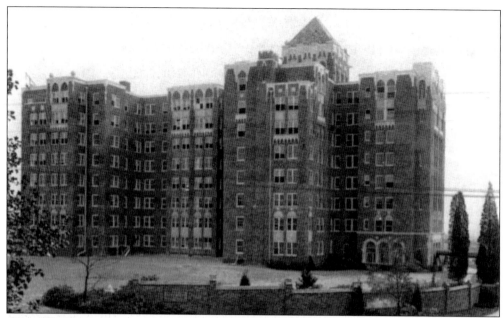

Originally planned to cover 28 acres at 4000 Cathedral Avenue, N.W., and to house over 1,000 luxury apartments, the Westchester apartment building was conceived by Washington developer Gustave Ring. The land was originally a cattle farm until Ring purchased it in 1929. Development on the first building, pictured here, began in March 1930. (Smithsonian.)

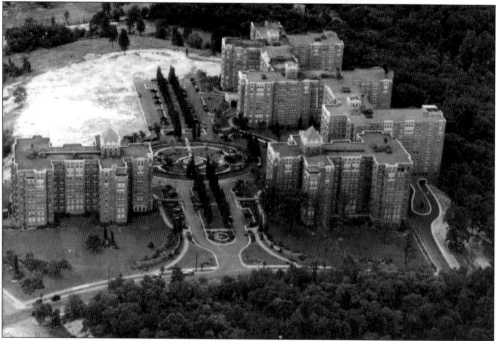

This rare aerial view of the Westchester shows the complex in 1933 with the alley of cedar trees and a sunken fountain in the middle. The Great Depression stopped plans to construct three additional buildings on the grounds shown at the upper left. Still, the luxury apartments were the largest in Washington until the erection of the Woodner in 1951. (Smithsonian.)

A number of Westchester apartments have step-down living rooms, which became popular in the 1930s. Although six floor plans were originally used, architect Harvey H. Warwick Sr. made numerous variations in different buildings so that very few apartments looked alike. (Smithsonian.)

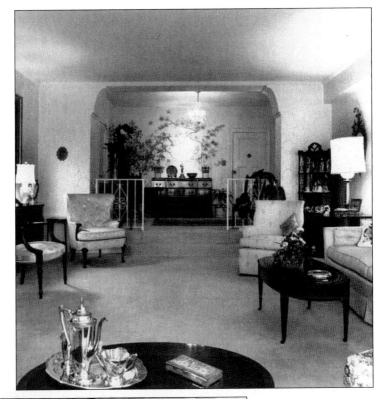

Some of the many luxurious amenities for residents of the Westchester were a gas pump and a uniformed chauffeur exclusively for the use of the residents. Other amenities included an onsite grocery store, drug store, and beauty shop. (Smithsonian.)

This massive pair of 18th-century English gates was added to the Westchester driveway entrance shortly after World War II. Robert W. Dowling, the president of the Westchester, located the gates while traveling in England. (Smithsonian.)

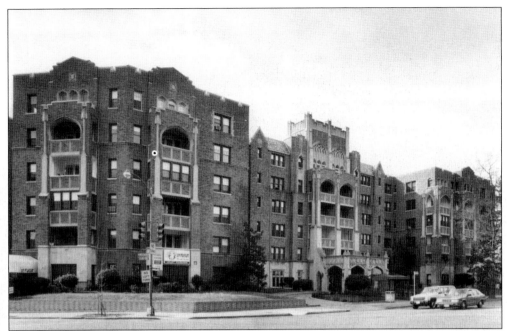

The five-story Alban Towers, designed by Robert O. Scholz in 1928–1929, was the largest apartment-hotel in Washington when it opened. Its Gothic Revival design was meant to blend in with some of its influential neighbors, such as the Washington National Cathedral and St. Albans School. Later, the building was purchased by Georgetown University for dormitory use. (Smithsonian.)

Alban Towers' front entrance was constructed of limestone and featured six corbels, five of which were medieval figures depicting male heads. The sixth corbel, seen here, was a tribute to famed aviator Charles Lindberg, who made his historic flight to Paris shortly before the opening of Alban Towers.

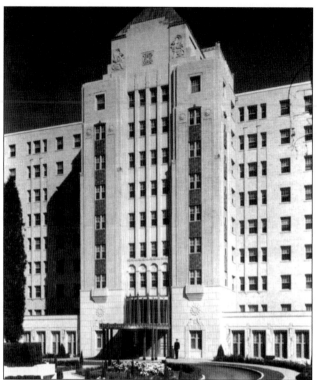

The impressive Kennedy-Warren apartment building at 3133 Connecticut Avenue, N.W., was built in 1931 and was designed by architect Joseph Younger. It was the first building in Washington where aluminum was extensively used on both the exterior and the interior. (LOC.)

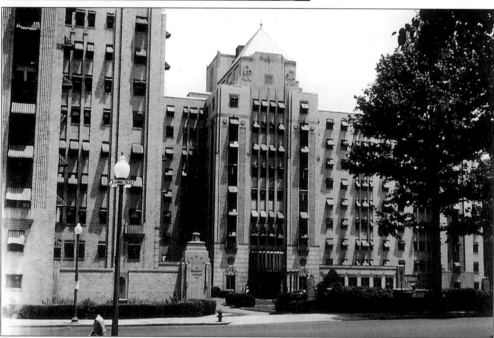

The Kennedy-Warren featured signature striped-canvas awnings above each window. Edgar S. Kennedy, who built several prominent apartment houses during the 1920s, partnered with developer Warren Monroe for the Kennedy-Warren project. However, the ill-fated Kennedy-Warren venture signaled Kennedy's bankruptcy in 1931. (HSW.)

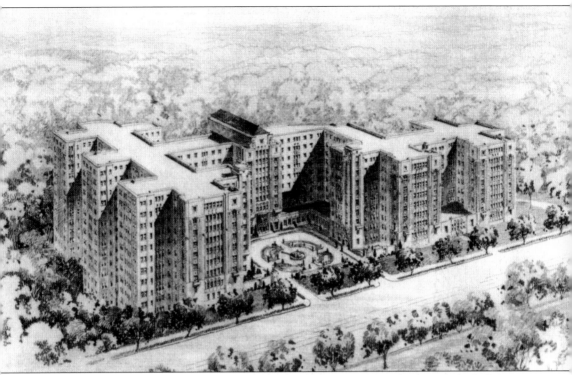

Architect Joseph Younger's original perspective of the Kennedy-Warren included a large wing to the right of the circular driveway that was never built due to the Great Depression and the bankruptcy of the building's original owners in 1931. Seventy-five years later, construction began in 2002 to complete Younger's original design. (LOC.)

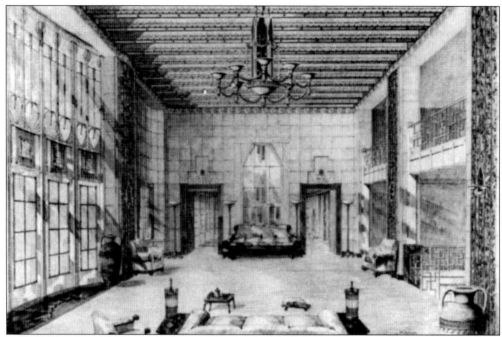

Younger envisioned the Kennedy-Warren lobby to feature Moderne chairs and sofas, as well as large ceramic vases and a curved bay of imported cathedral glass windows at the main entrance. Spacious step-down parlors were designed for bridge parties and private gatherings. (LOC.)

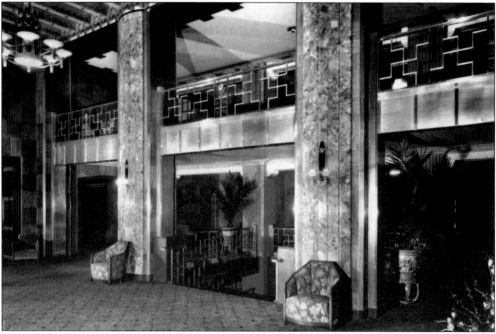

The Kennedy-Warren lobby featured an innovative Aztec painted ceiling with gold and pastel colors, as seen in this 1933 photograph. The marble facing on the columns, as well as the decorative metal railings, all stand today, helping the building remain one of the finest examples of art deco design in Washington. (LOC.)

Many Kennedy-Warren kitchens retain their original design, including a pair of china cabinets that separated the kitchen from the dining area. The features were well documented by historian James M. Goode. The elegant design of the building and the numerous amenities resulted in long-standing residents. (Smithsonian.)

George Santmyers designed the Delano, one of more than 400 apartment buildings he designed in Washington between 1916 until his death in 1960. In addition to many elaborate apartment buildings, he also was notable for his small garden apartment homes. (Smithsonian.)

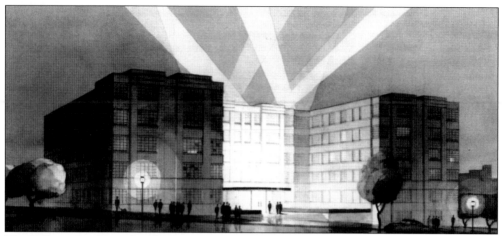

The Delano apartment building was constructed in 1941 by Sidney Brown and designed by prolific architect George T. Santmyers, whose original 1941 watercolor perspective of the building is seen here. The majority of the 125 units in the Delano were one-bedroom residences and featured bathrooms laid in beautiful tile patterns. (Smithsonian.)

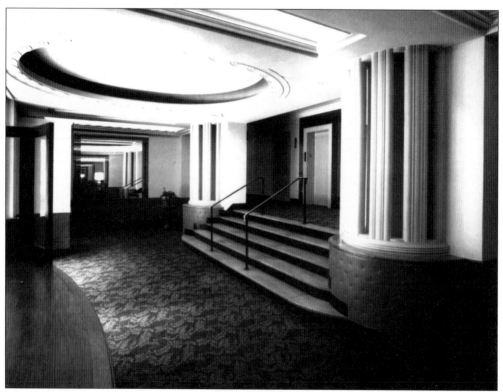

The Delano's art deco lobby is notable for its blue mirrors and blue leather wainscoting and wrought-iron balustrades. (Smithsonian.)

Six

THE WASHINGTON NATIONAL CATHEDRAL

Washington, D.C. is home to America's most poignant and memorable monuments and symbols; however, few can rival the Washington National Cathedral for its beauty and impressive stature. The idea for a National Cathedral was born in 1791, when President George Washington commissioned Maj. Pierre L'Enfant to design an overall plan for the future seat of government following the city's selection as the nation's capital by Congress. Included in L'Enfant's plan was a "church intended for national purposes, such as public prayer, thanksgiving, funeral orations, etc., and assigned to the special use of no particular Sect of denomination, but equally open to all."

Efforts to build the Washington National Cathedral, officially named the Cathedral Church of Saint Peter and Saint Paul, stalled for over a century until 1893 when Congress granted a charter to the Protestant Episcopal Cathedral Foundation of the District of Columbia. President Benjamin Harrison's signature was the genesis of the Washington National Cathedral. The Cathedral School for girls was established in 1900, and in 1905, the St. Albans School for boys was founded, as both schools preceded the actual Cathedral itself.

The first bishop of Washington, Rev. Dr. Henry Yates Satterlee, was instrumental in securing land atop Mount St. Alban for the Cathedral. On September 29, 1907, President Theodore Roosevelt, in front of a crowd of 10,000 onlookers, struck the cathedral foundation stone with the same mallet used by George Washington to dedicate the United States Capitol in 1793. A stone used in the foundation symbolically originated from a field near Bethlehem.

Beginning with President Theodore Roosevelt's attendance at the dedication, every United States president since has either attended services or visited the Washington National Cathedral. It was also the longest-running construction site in Washington. On September 29, 1990—83 years to the day of the dedication—the west towers of the Cathedral were completed, the final stage of construction that brought the total cost of the building to $65 million, all of which was raised by private donations.

The Washington National Cathedral's stunning façade is only equaled by its amazing list of interior and exterior features—215 stained glass windows illuminate the interior, while 112 gargoyles adorn the outside. Additionally, more than 10,500 pieces of stained glass compose the picturesque West Rose window, while the Space Window contains a piece of lunar rock presented to the Cathedral by the astronauts of Apollo XI. Although the Cathedral spans a region that is not exclusively Woodley Park, the authors choose to include it in this book as a testament to its powerful influence in the area.

The creation of the Cathedral School for Girls was made possible by an impressive $200,000 donation made by Mrs. Phoebe A. Hearst, pictured here in 1898. Shortly thereafter, competitive drawings from prominent architects resulted in the selection of R.W. Gibson of New York for the design of the impressive building. (LOC.)

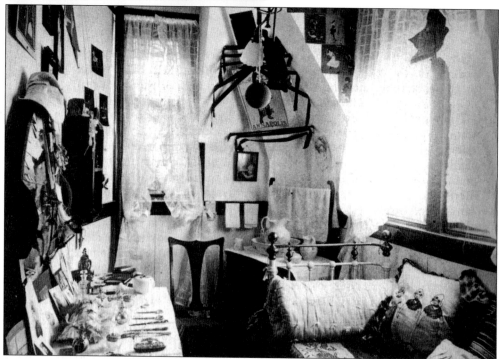

The National Cathedral School for Girls opened its doors in October 1900. Its first catalogue stated, "It is an essential feature that each resident girl occupies a single room, and has the opportunity for a degree of private life and quiet thought." One of the typical girls' rooms is pictured here. (Author.)

The first graduate of the Cathedral School for girls was Edith Abercrombie-Miller, seen here on commencement day in May 1901, which was held in St. Hilda's Hall. (LOC.)

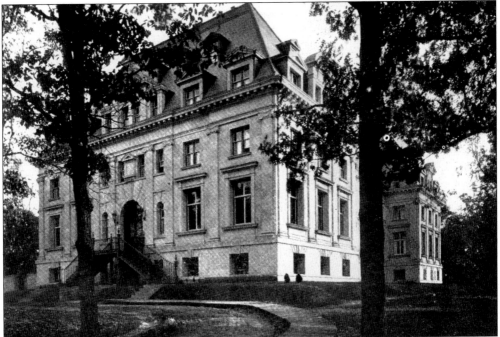

The National Cathedral School for Girls opened its doors in 1900 with 16 day and 32 boarding students. The founding of the school was primarily orchestrated by the first Episcopal Bishop of Washington, Henry Yates Satterlee, and by Phoebe Apperson Hearst, a philanthropist and educator who aimed to establish a school in Washington that would offer an excellent academic program for young women. (MLK.)

This well-lit classroom at the Cathedral School for Girls was photographed in 1909. Teacher Miss Handy apparently taught the young girls that "no one could consider herself a lady unless she could sit on a sharp object unexpectedly without uttering a cry or changing her expression." (Author.)

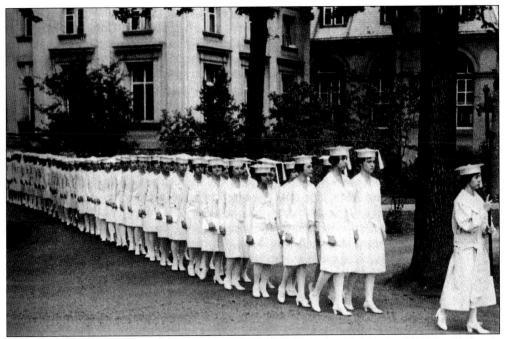

The head of physical education at the Cathedral School for Girls from 1909 to 1934 was Margaret M. Bogenrief, who was known for the strict and regimented commencement lines, seen here led by Helen Chickering in 1929. (LOC.)

Principal Katherine Lee headed the Cathedral School for Girls from 1950 to 1968. Her dog, Domine, was immortalized by Cathedral stone carver Constantine Seferlis as a gargoyle on the tower. Miss Lee herself titled this picture "Four Gargoyles in Search of a Cathedral." (LOC.)

The inspiration for St. Albans School, a classroom of which is shown in this 1916 image, can be traced back to Harriet Lane Johnston, the niece of President James Buchanan and one of the most important women of her day. When her two young sons died tragically at the ages of 12 and 14, she decided to set up a school for cathedral choirboys. The first building at St. Albans, in 1905, was known as "The Lane Johnston Choir School for Boys of the Washington Cathedral." Many future influential men were schooled at St. Albans, including former Vice President Al Gore, who graduated in 1965. (LOC.)

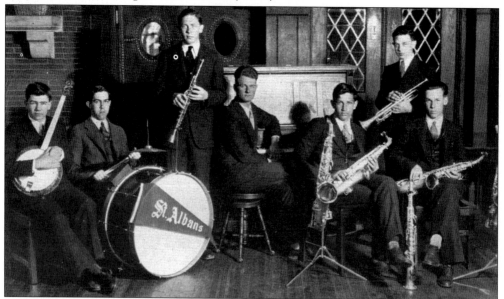

Members of the St. Albans orchestra are pictured here in their 1931 yearbook pose. Of the 40 pieces in their musical repertoire that year, they "had mastered more than half." (LOC.)

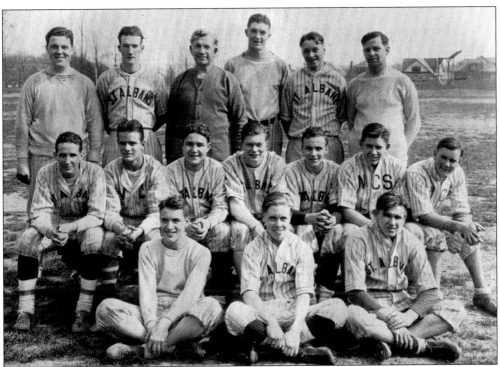

The St. Albans baseball team is pictured here in 1931. Their game against Georgetown Prep that year was called a 6–6 tie after the twelfth inning, due to the darkness that had overcome the field that night. (Author.)

This "general view" of St. Albans school appeared in the school's 1931 yearbook. The senior class that year voted Joan Crawford its favorite actress, Mickey Mouse as its favorite actor, and the most needed items at school as a gym, swimming pool, and school "traditions." (Author.)

On September 29, 1907, the foundation stone was laid for the formation of the Washington National Cathedral. The Braddick stone used came from a field near Bethlehem and was inset into a larger piece of American granite. At the Braddick Stone Dedication at the Cathedral in November 1907 (pictured here), President Theodore Roosevelt and the Bishop of London spoke to a crowd of 10,000. (HSW.)

This is the first known construction photograph taken of the National Cathedral, showing the excavation and Foundation Stone protected by a series of planking. The Cathedral, built in the traditional "stone-on-stone" method with no structural steel, cost $65 million to build, all of which was raised through private donations. (LOC.)

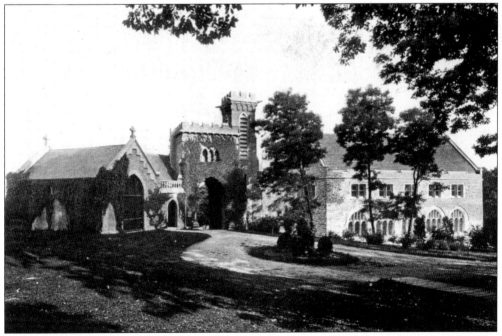

The Little Sanctuary and Choir School, as seen here, are part of the Cathedral Close. The original land site for the Washington National Cathedral was 30 acres large and was purchased in 1898 for $245,000. Two additional parcels of land were later purchased to bring the total area to 57 acres. (MLK.)

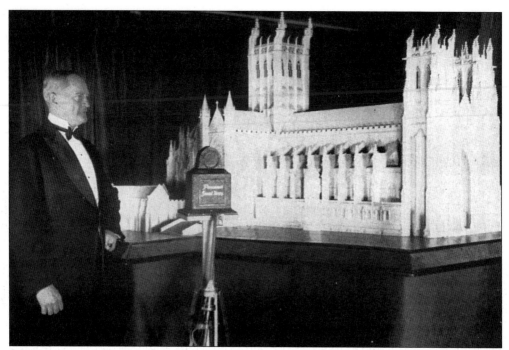

As Chairman of the National Committee for the National Cathedral, Gen. John J. Pershing was photographed in front of a working model prior to his live radio broadcast before 40 million people in the 1920s. During this broadcast he expounded on the Cathedral as a modern fulfillment of George Washington's early vision for the city. (Author.)

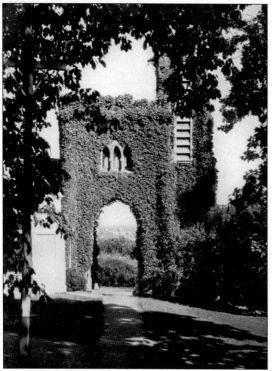

The All Hallows gate in the Little Sanctuary was covered with English ivy gathered at Canterbury Cathedral in the United Kingdom and has served as a backdrop for open-air services at the Peace Cross services. (Author.)

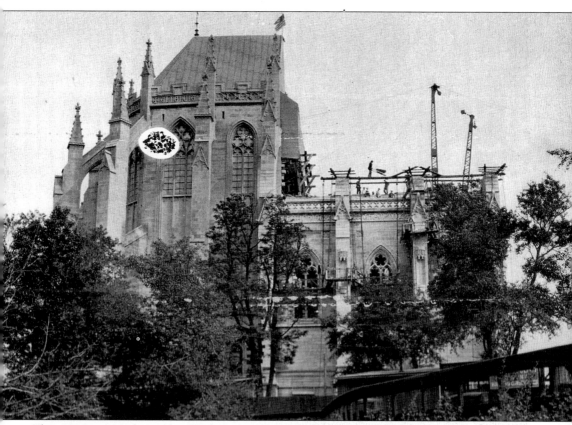

This 1926 image shows the Washington National Cathedral in one of the many stages of construction. From September 29, 1907 to September 29, 1990, the Cathedral was under construction, except during World Wars I and II and during financial difficulties. However, since the completion of the Bethlehem Chapel in 1912, daily services have been held. The Washington National Cathedral is the only cathedral in the world that is the seat of two bishops—the Presiding Bishop of the Episcopal Church USA and the Episcopal Bishop of Washington. (MLK)

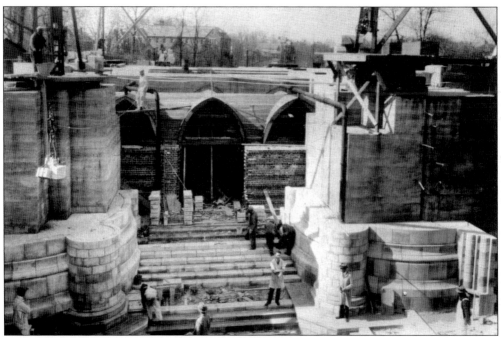

This 1926 construction image shows the massive concrete core of the piers that would eventually carry the masonry load of the central tower, which was built decades later. (LOC.)

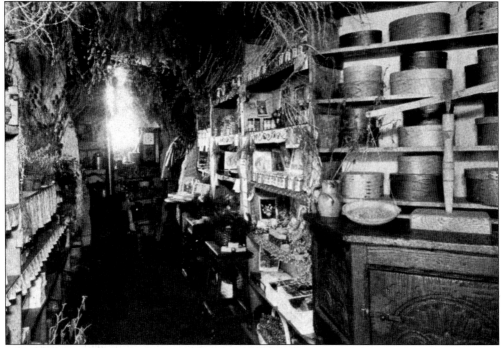

The Herb Cottage, seen here c. 1935, is located adjacent to the Washington National Cathedral at Wisconsin Avenue and Massachusetts Avenue. Operated by All Hallows Guild, the shop is open daily and sells an array of goods, including jams, preserves, bread mixes, sauces, salsa, and, of course, herbs. (LOC.)

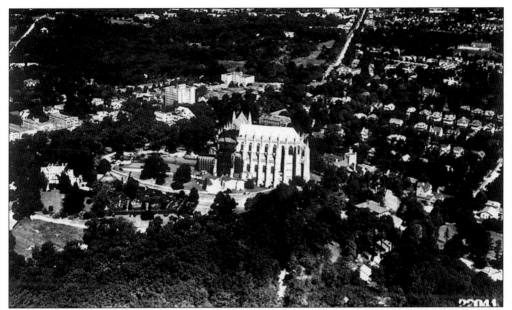

This aerial shot shows one of the many stages of development of the Washington National Cathedral. One of the future improvements would include the enclosure of the cathedral nave in 1972. It was dedicated in 1976 in a series of ceremonies attended by the Queen of England, the President of the United States, the Archbishop of Canterbury, and thousands of other worshippers. The final completion of the west towers was in September 1990. (HSW.)

Stone carver Gino Bresciani is seen here completing a massive finial for the tower. He was known for his love of singing over the noise of his pneumatic air hammer. (LOC.)

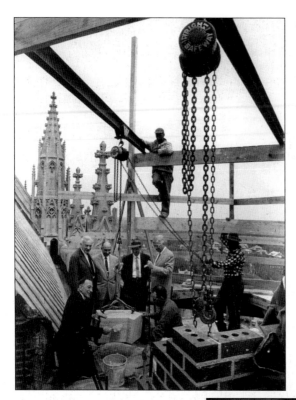

Rev. Francis B. Sayre Jr., the dean of the Washington National Cathedral, sets the first stone in the base of the Gloria in Excelsis tower in this 1961 *Washington Post* photograph. The Cathedral's center tower, completed in 1964, is as tall as a 30-story building, and at 676 feet above sea level, its top is the highest point in the District of Columbia. (Photograph by Wally McName.) (MLK.)

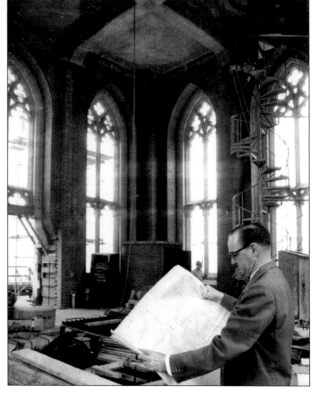

In this 1963 *Washington Post* image, Richard Feller, clerk of the Works, studies plans for the interior of the new carillon tower. The Washington National Cathedral is the sixth-largest cathedral in the world and the second largest in the United States. (St. Peter's Basilica in Rome is the largest church in the world and Saint John's in New York City is the largest cathedral in the United States). (MLK.)

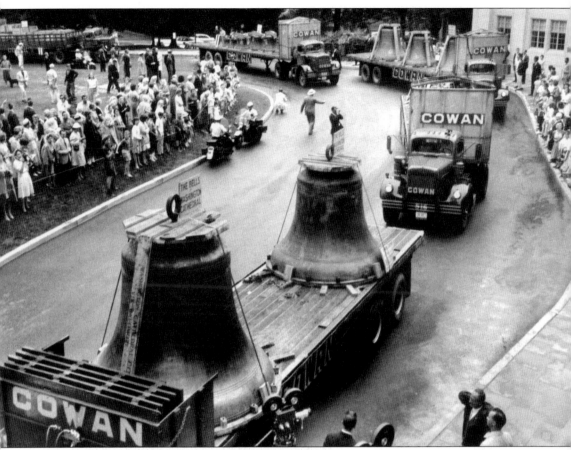

In June of 1963, 53 carillon and 10 English ring bells arrived at the Cathedral site and were shortly thereafter hoisted into place within the two towers. They had arrived in the port of Baltimore from the Taylor Bell Foundry in England where they were manufactured. (LOC.)

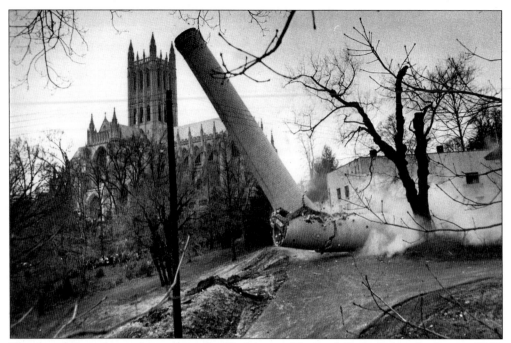

The demolition of a smoke stack at the Washington National Cathedral took place in 1969. Environmental concerns mandated new boiler smoke filters to eliminate the staining of the Cathedral stone and eliminating the need for the 125-foot smokestack. (MLK.)

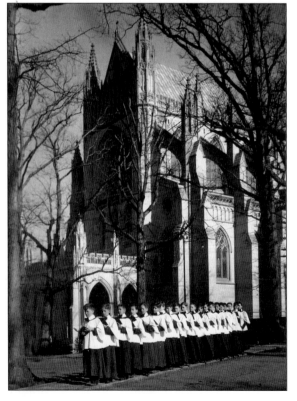

The Cathedral Church of Saint Peter and Saint Paul, the official name of the Cathedral, is more commonly called the Washington National Cathedral. On March 31, 1968, Rev. Dr. Martin Luther King Jr. preached his last Sunday sermon at the Cathedral, and a memorial service for King was held there five days later. (MLK.)